W9-CBK-624

ART OF COLORING

Disney

HOCUS POCUS

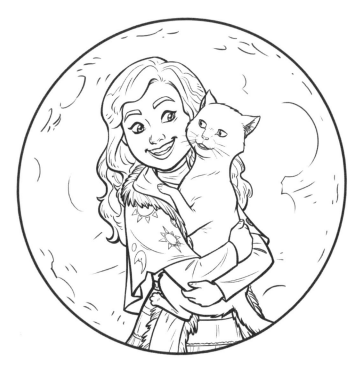

Special thanks to Cindy Plourde
for her contributions to the artwork.

— *D.T.*

Copyright © 2022 Disney Enterprises, Inc. All rights reserved.

Published by Disney Editions, an imprint of Buena Vista Books, Inc. No part of this book may be reproduced or transmitted in any form or by any means, electronic or mechanical, including photocopying, recording, or by any information storage and retrieval system, without written permission from the publisher.

For information address Disney Editions, 1200 Grand Central Avenue, Glendale, California 91201

Printed in the United States of America

First Paperback Edition, July 2022
1 3 5 7 9 10 8 6 4 2

ISBN 978-1-368-07650-0

FAC-034274-22161

Visit www.disneybooks.com

ART OF COLORING

Disney

Hocus Pocus

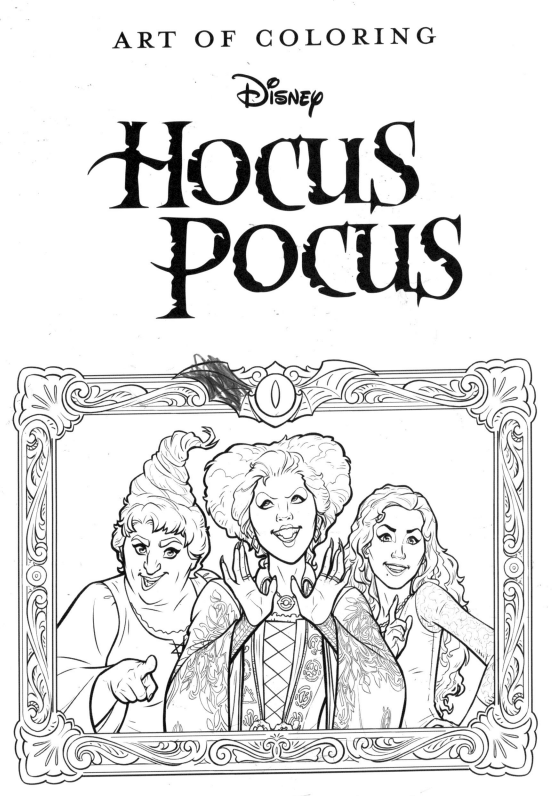

Illustrated by Devin Taylor

EDITIONS

Los Angeles · New York

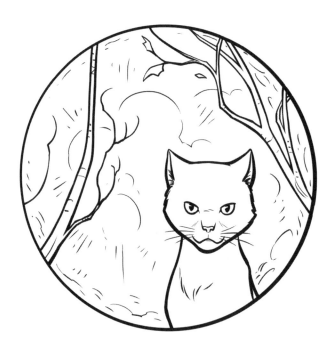

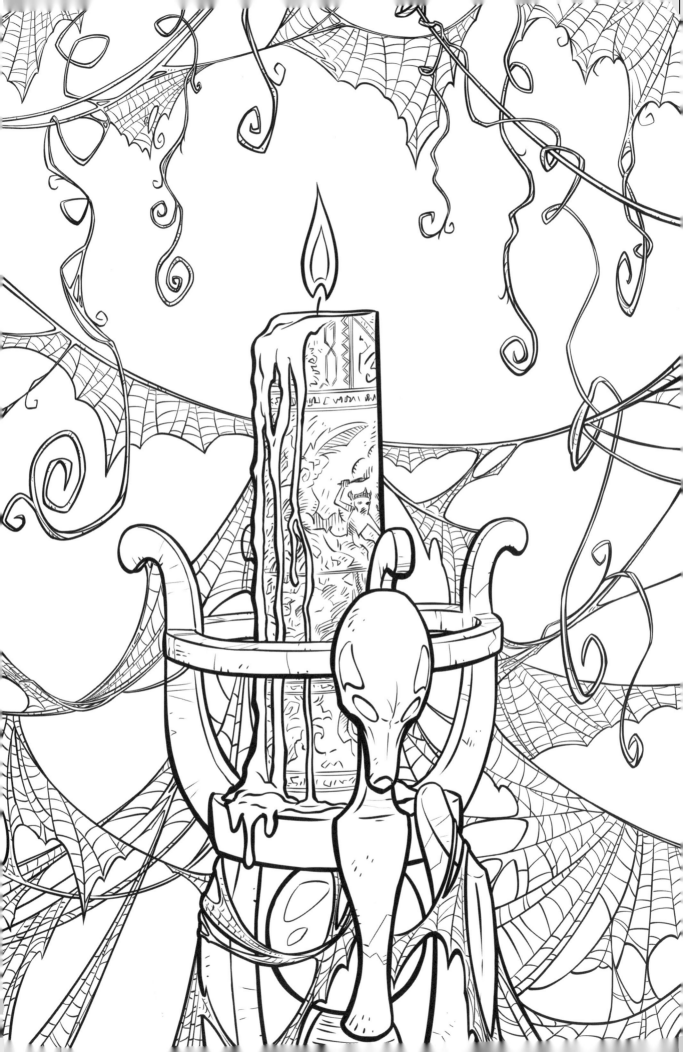

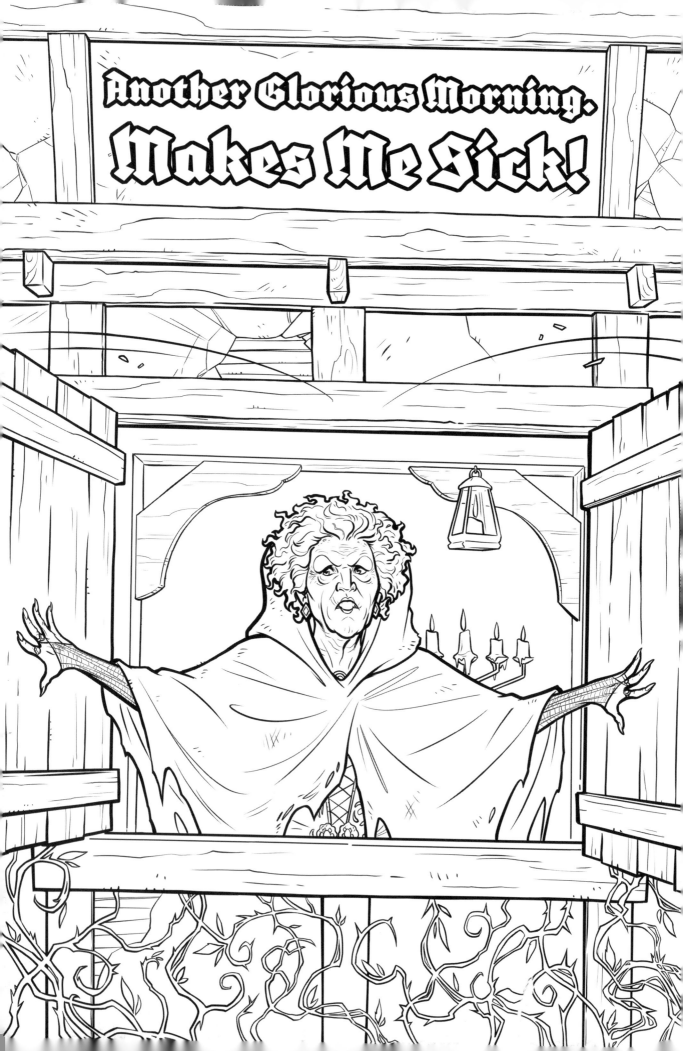

Bring to a full rolling bubble.
Add two drops oil of boil.
Mix blood of owl with the herb that's red.
Turn three times, pluck a hair from my head.
Add a dash of pox and a dead man's toe.
Newt saliva.
Add a bit of thine own tongue.

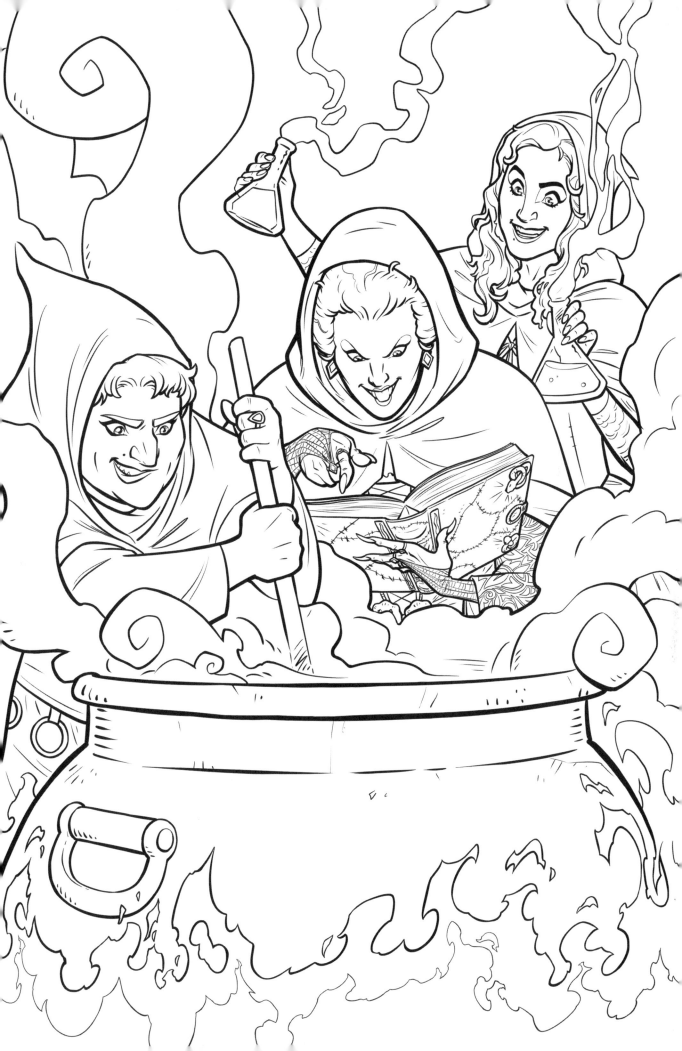

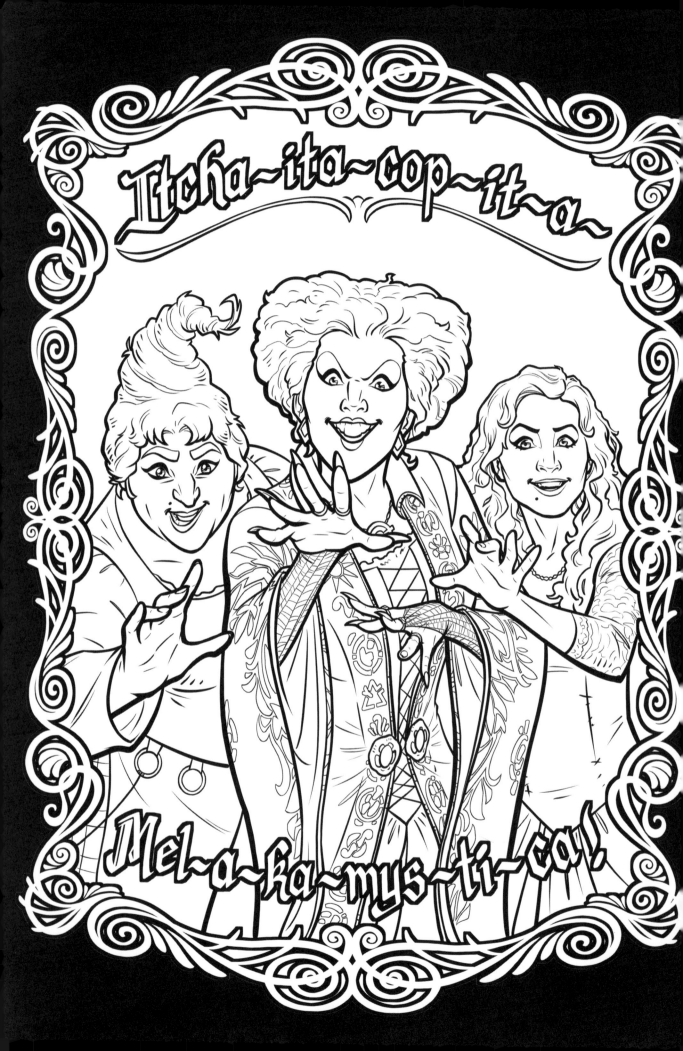

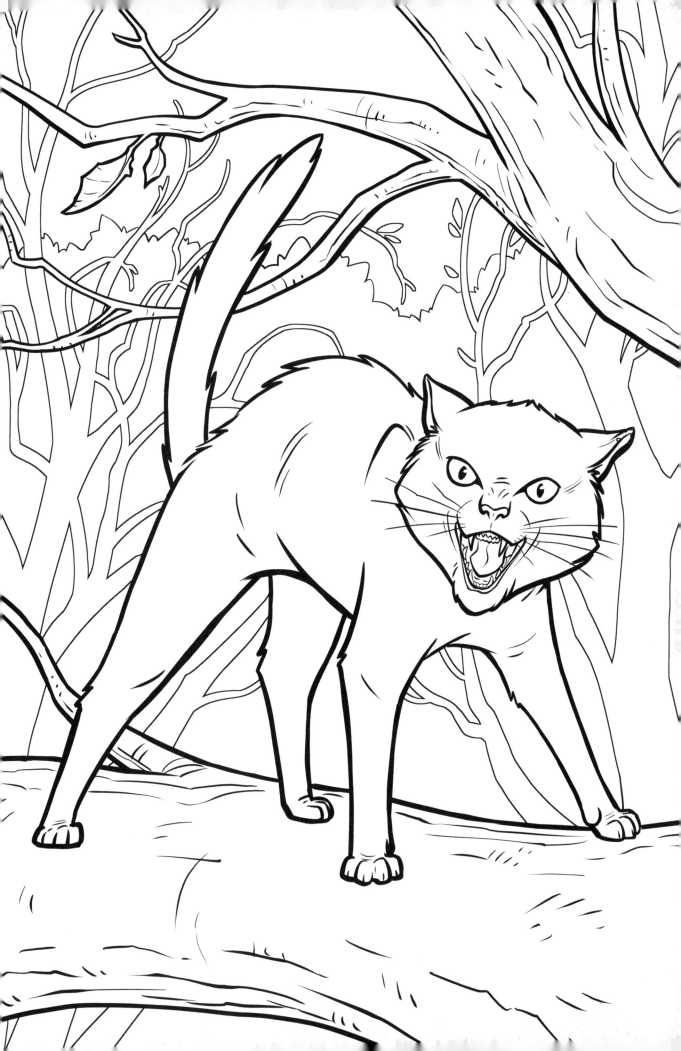

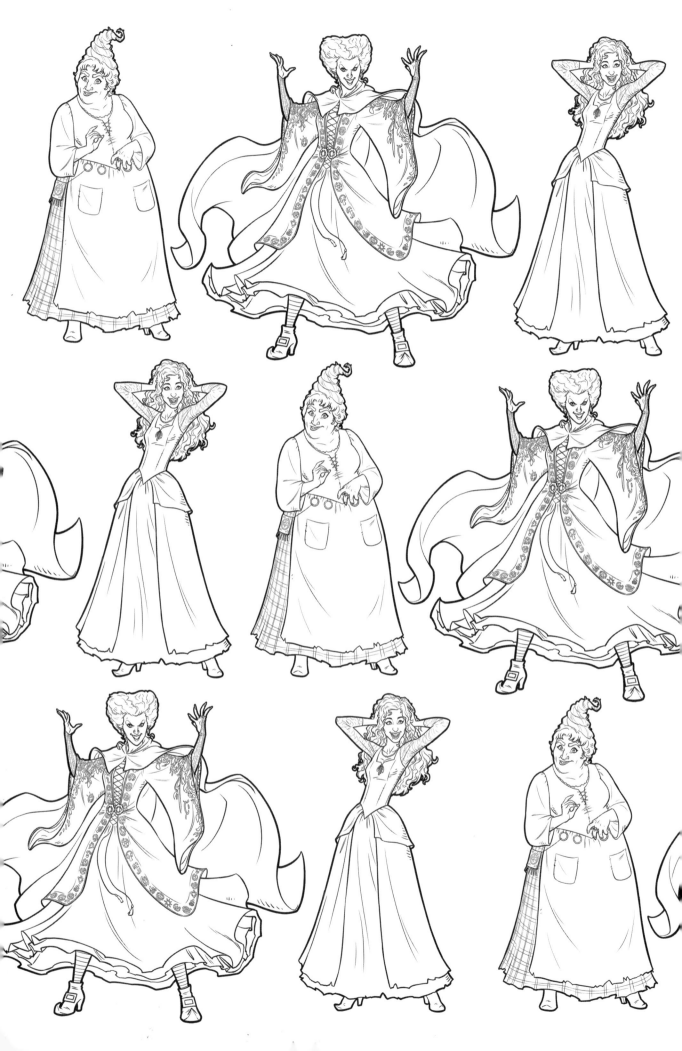

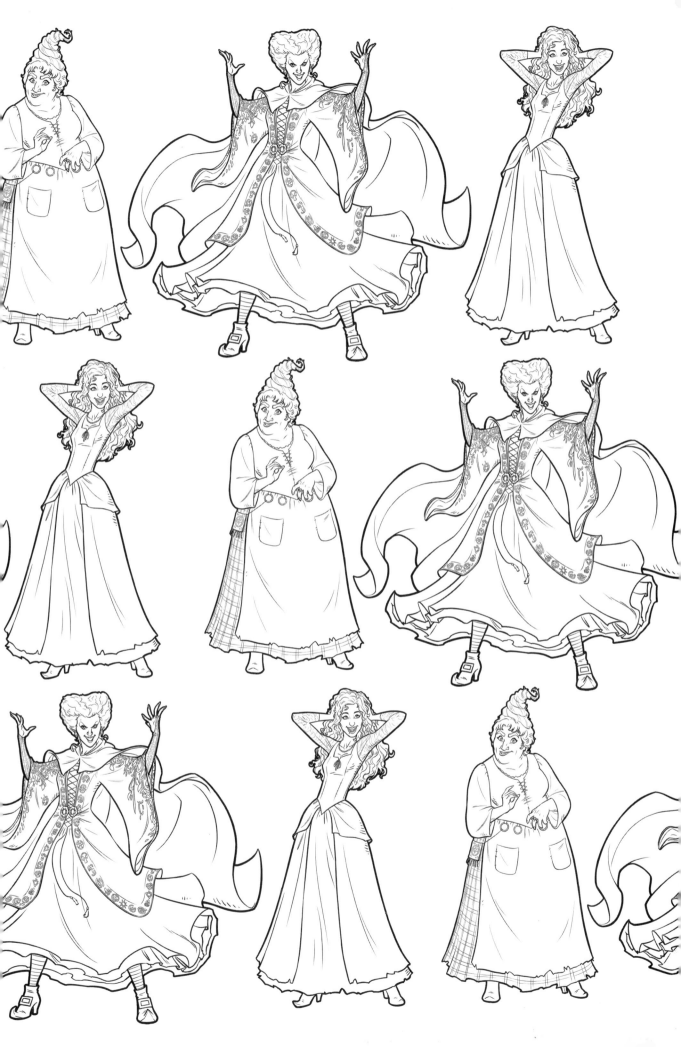

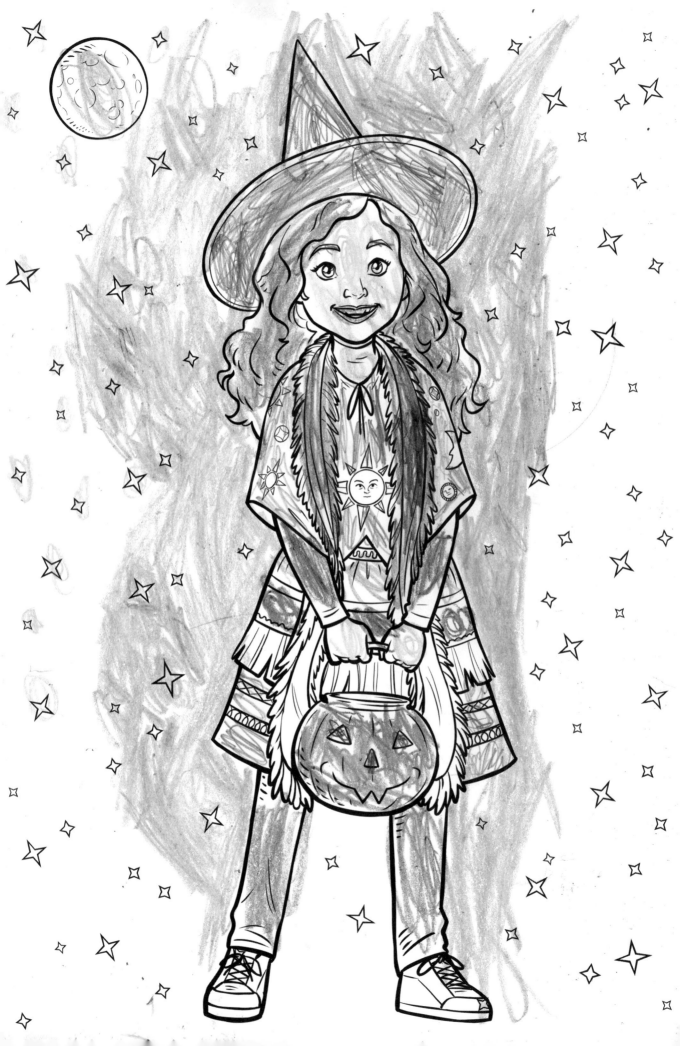

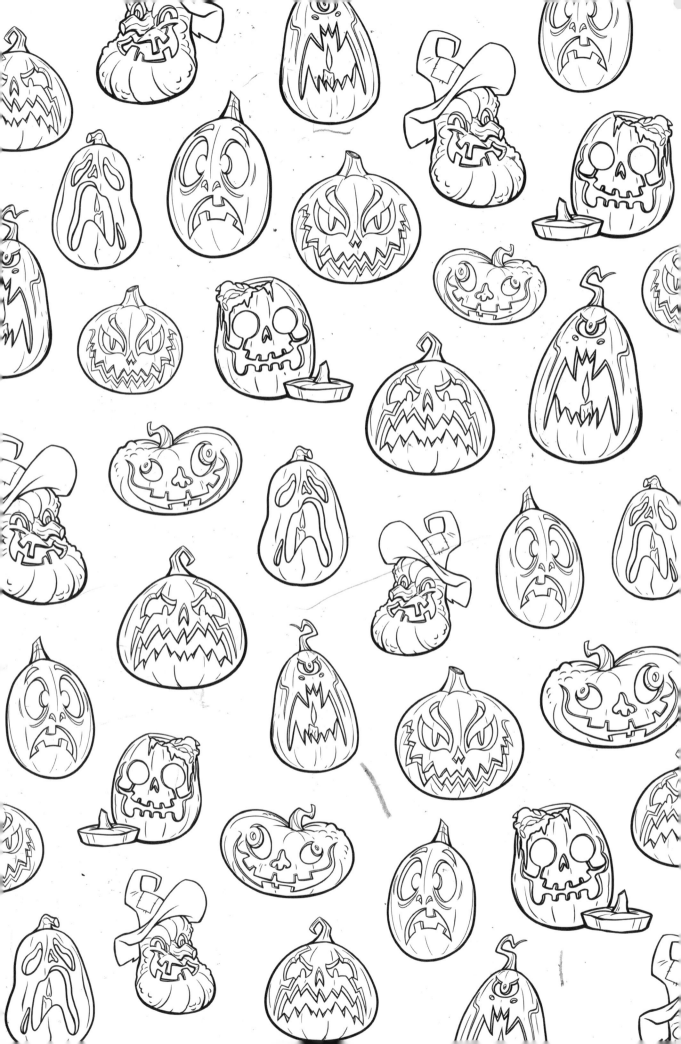

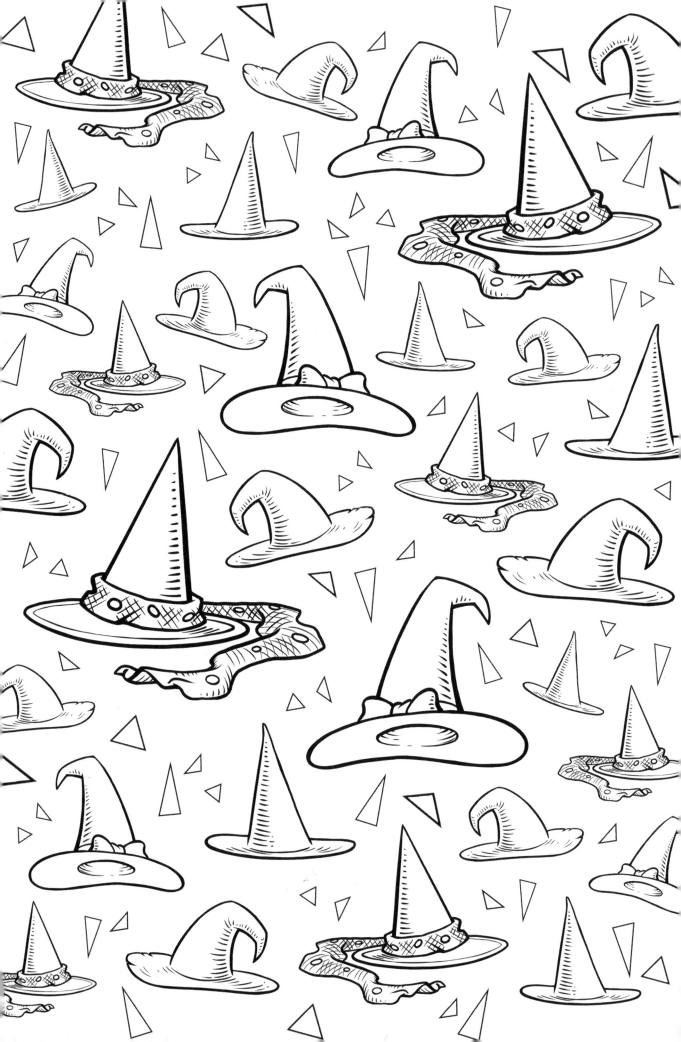

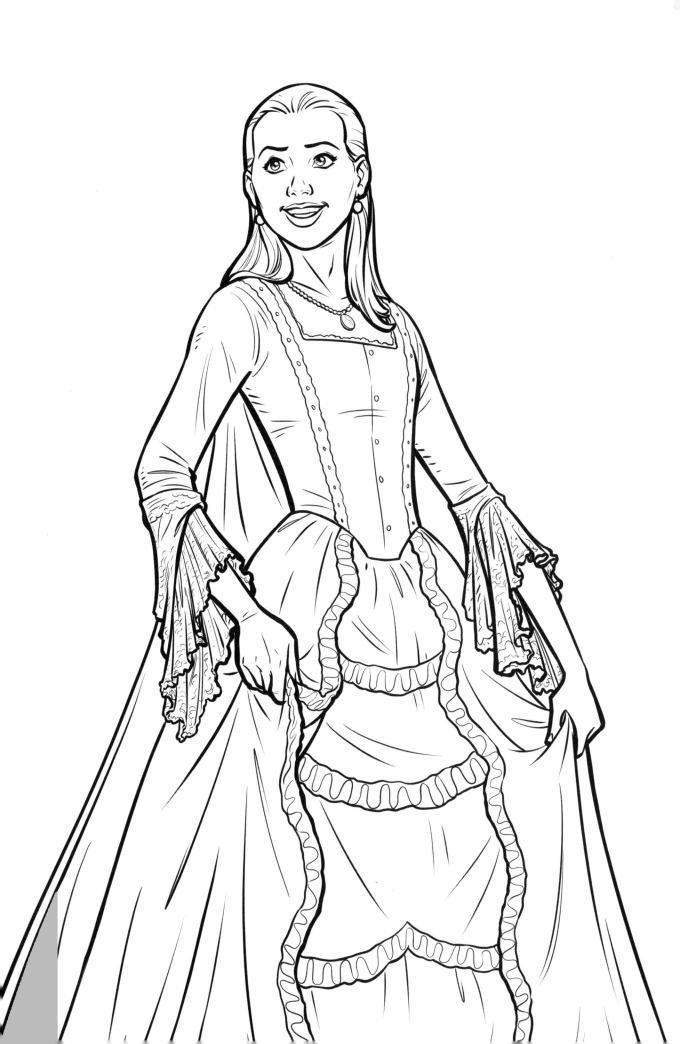

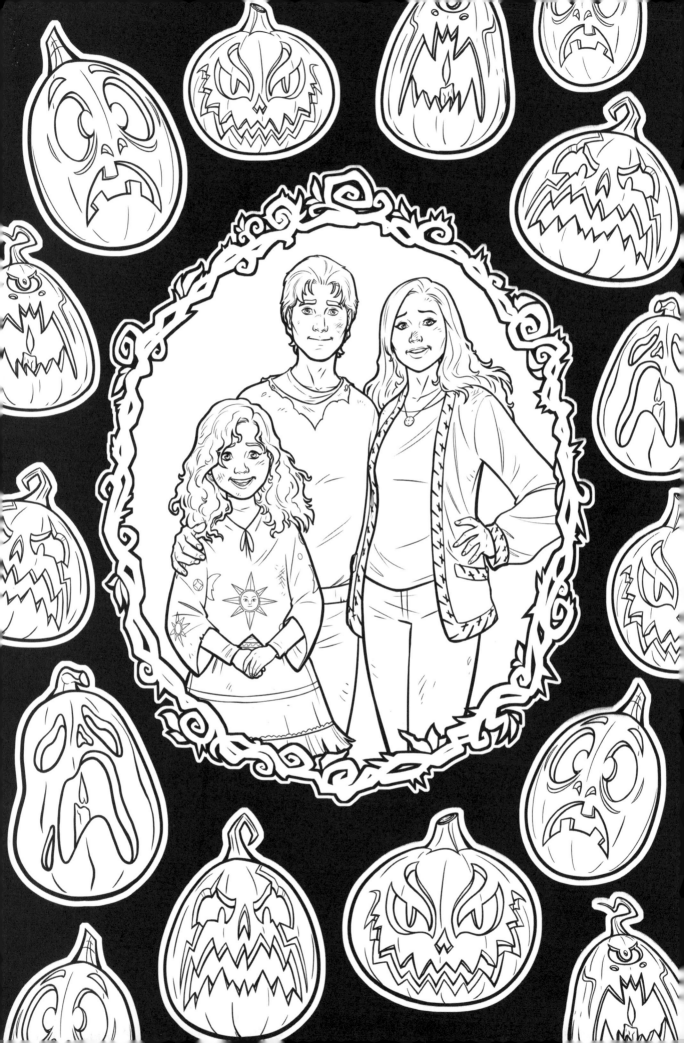

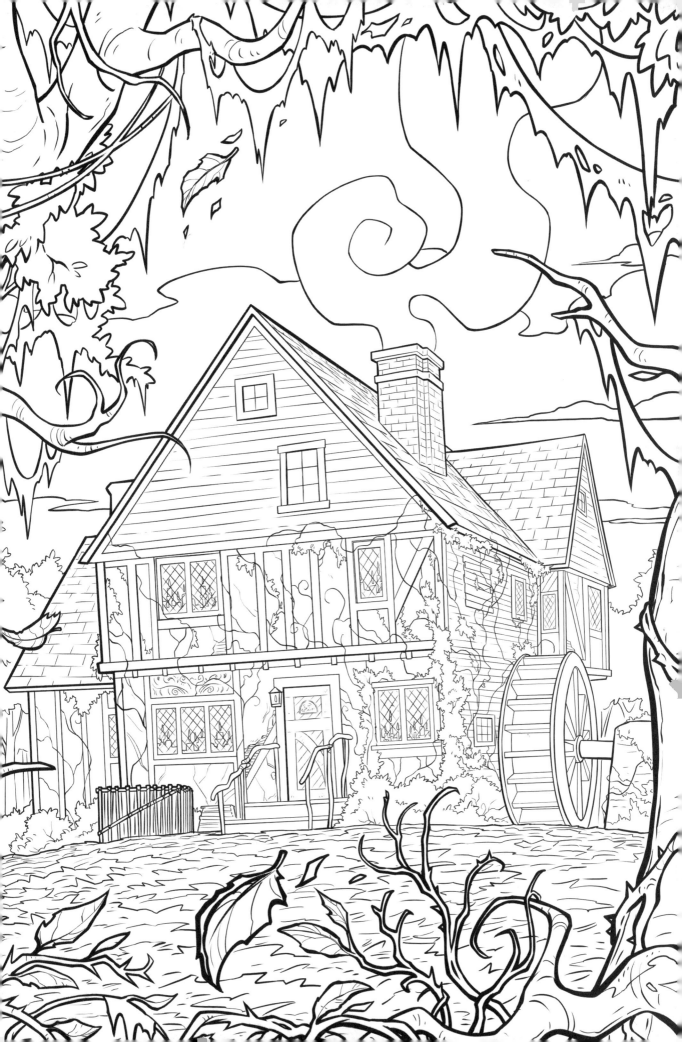

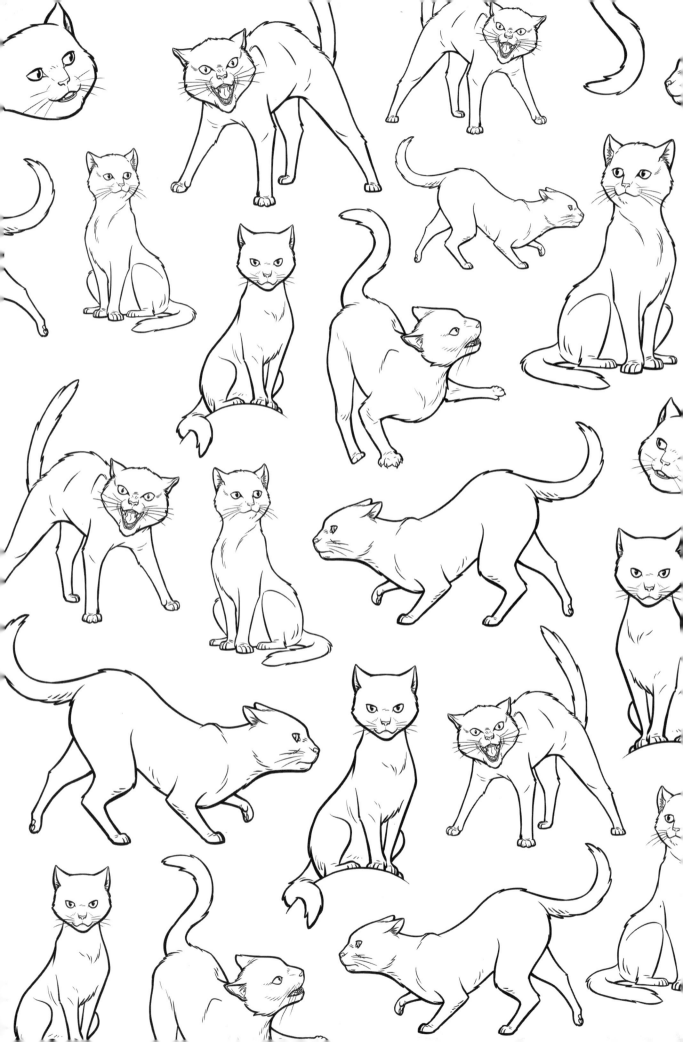

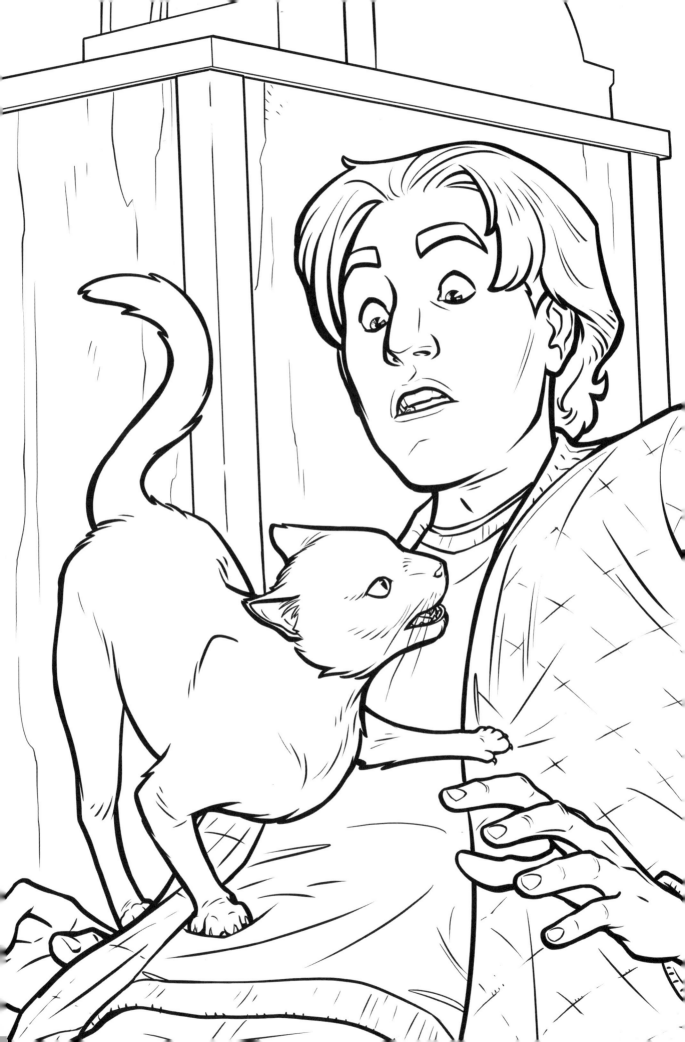

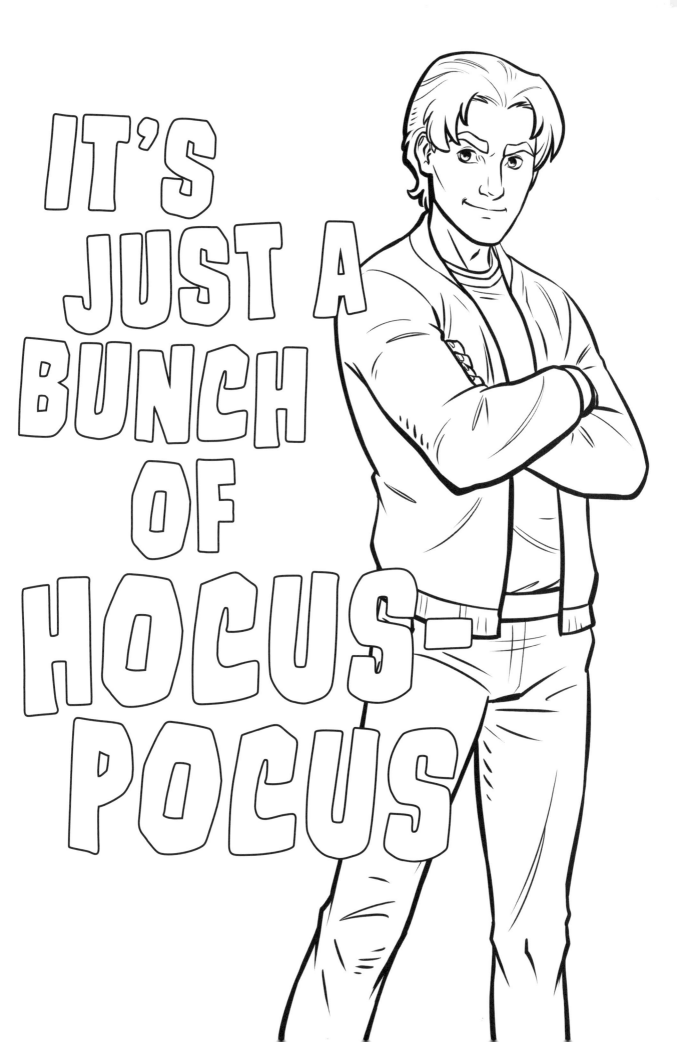

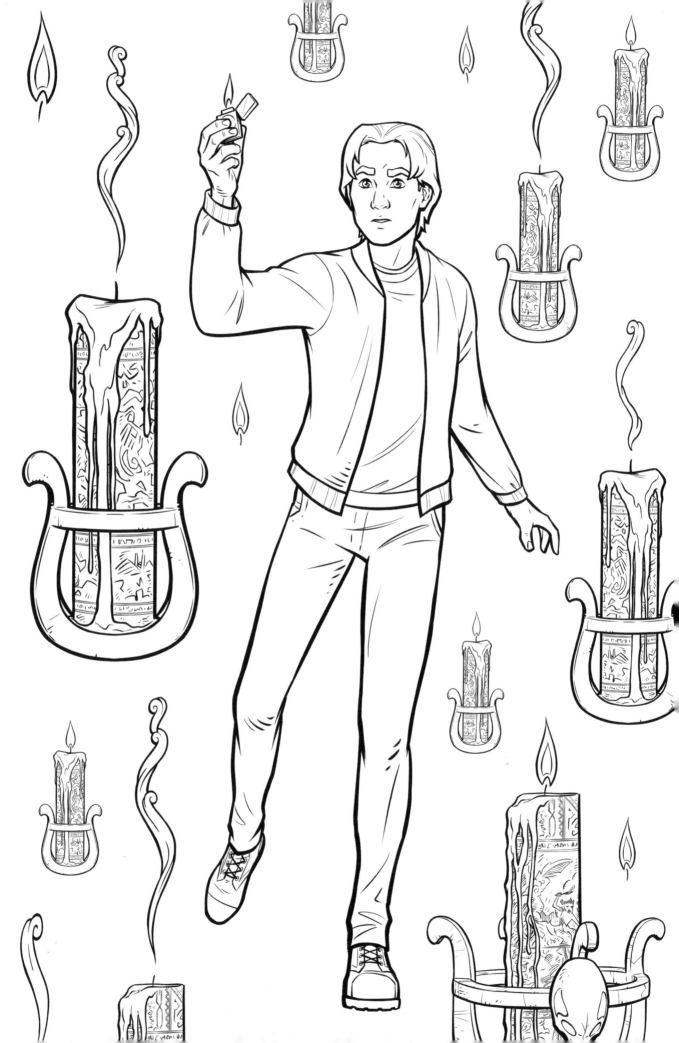

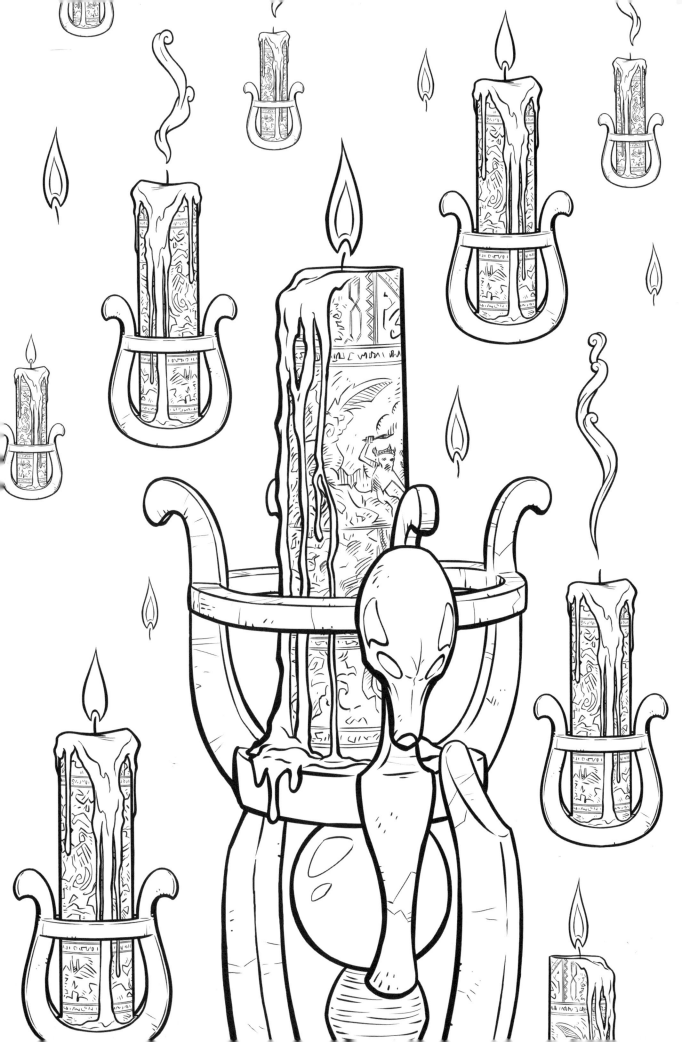

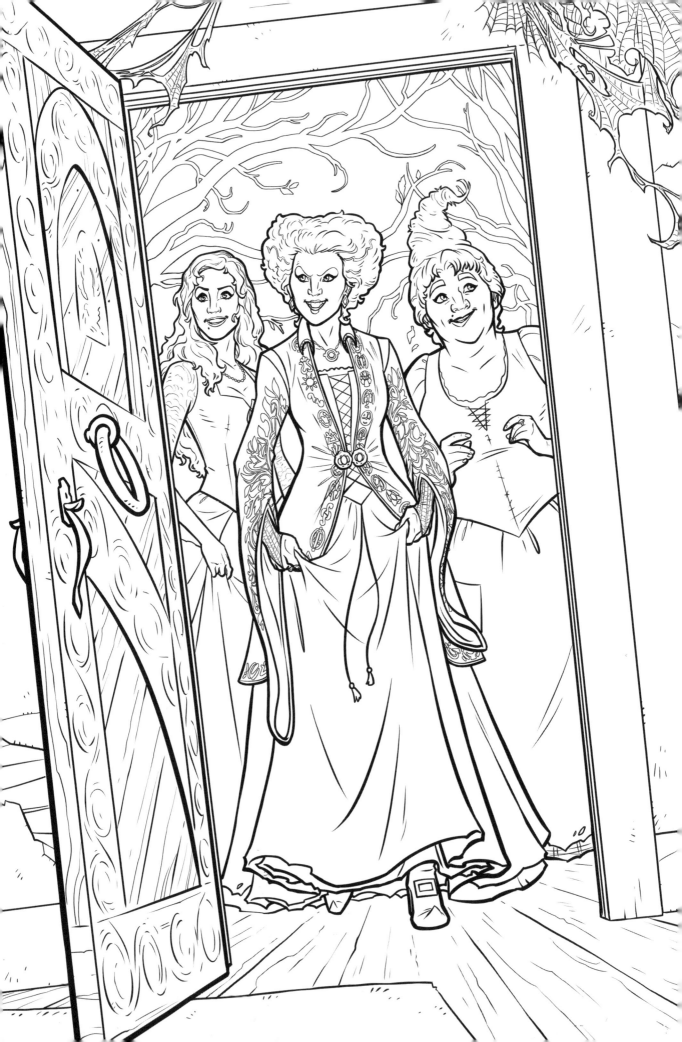

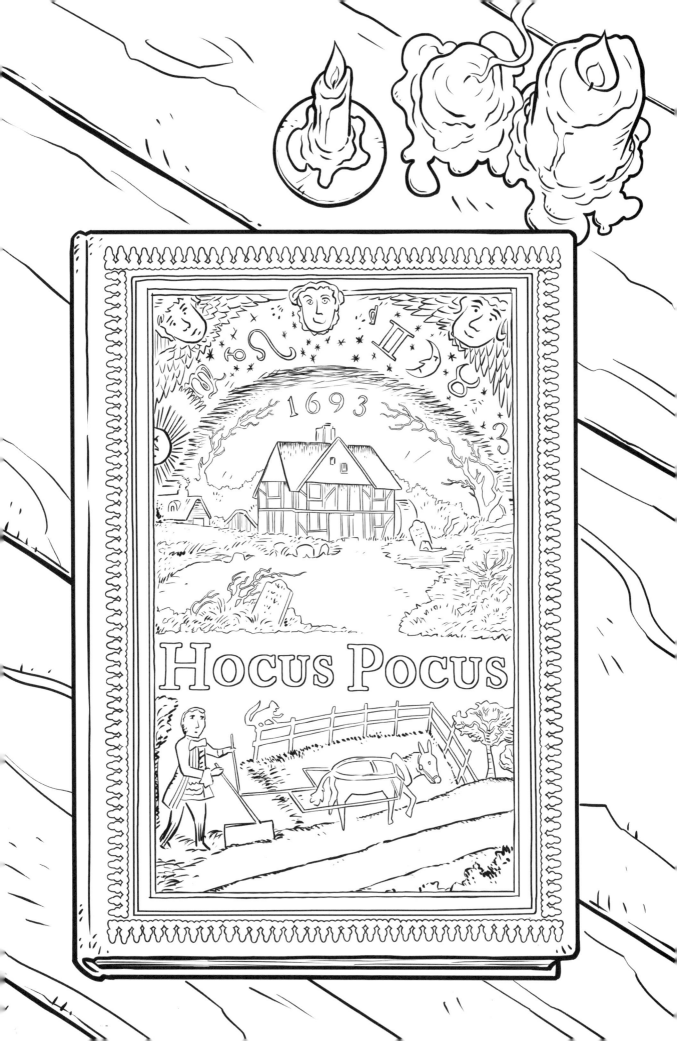

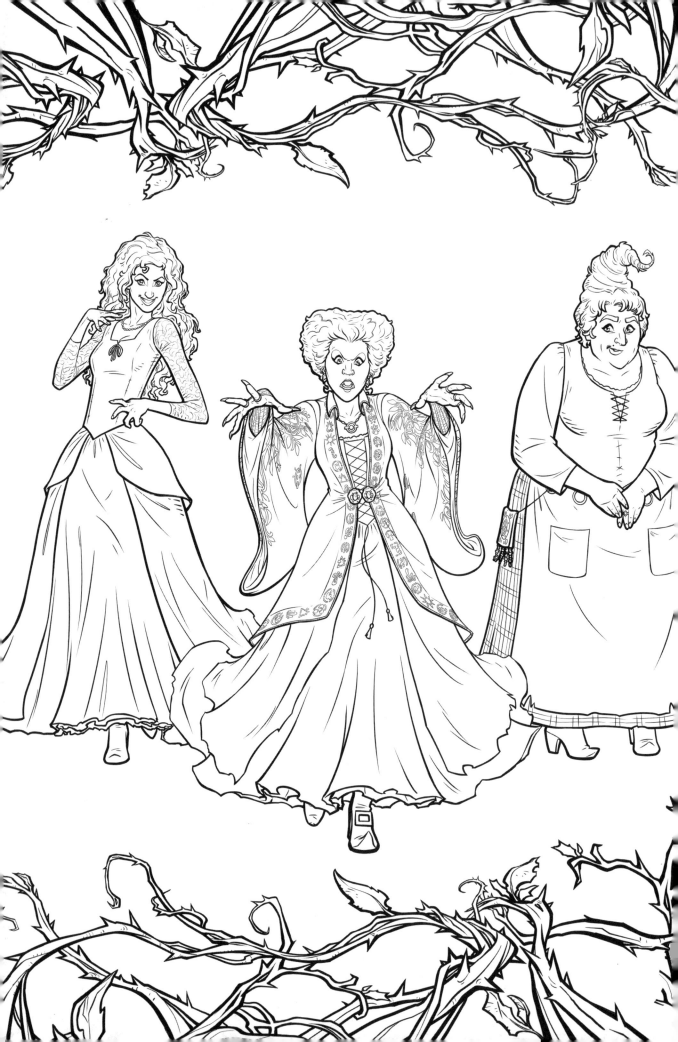

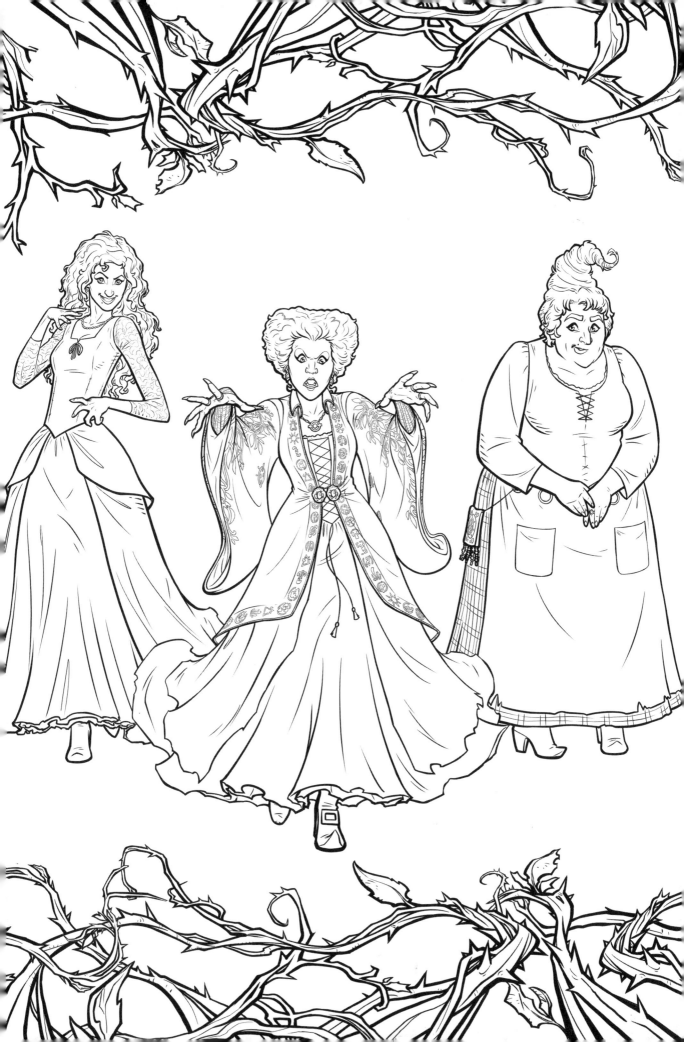

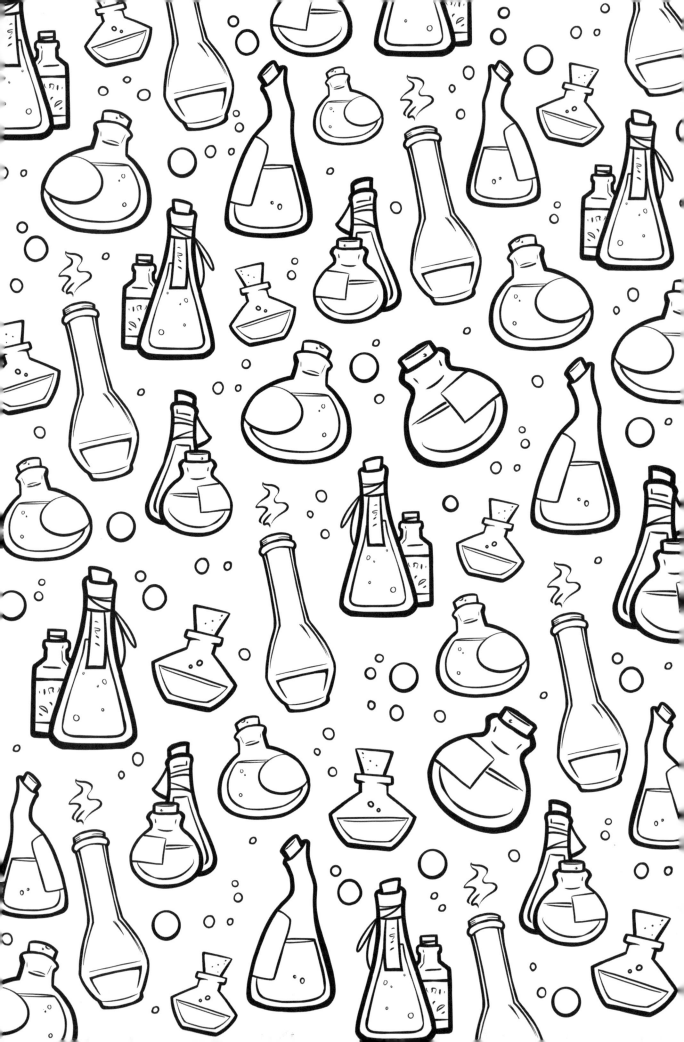

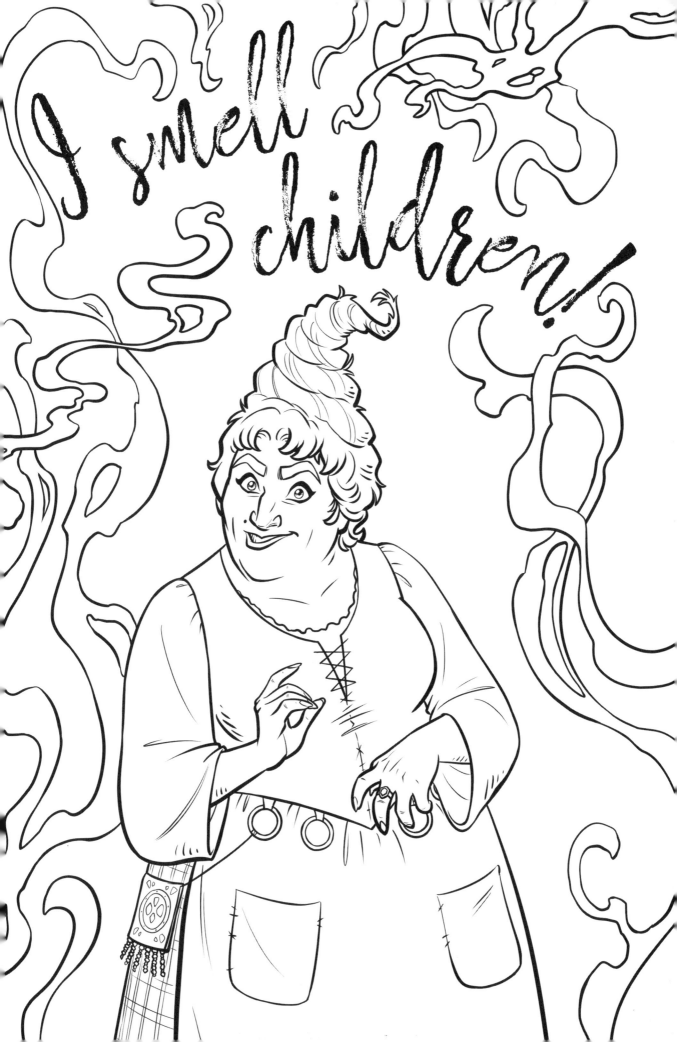

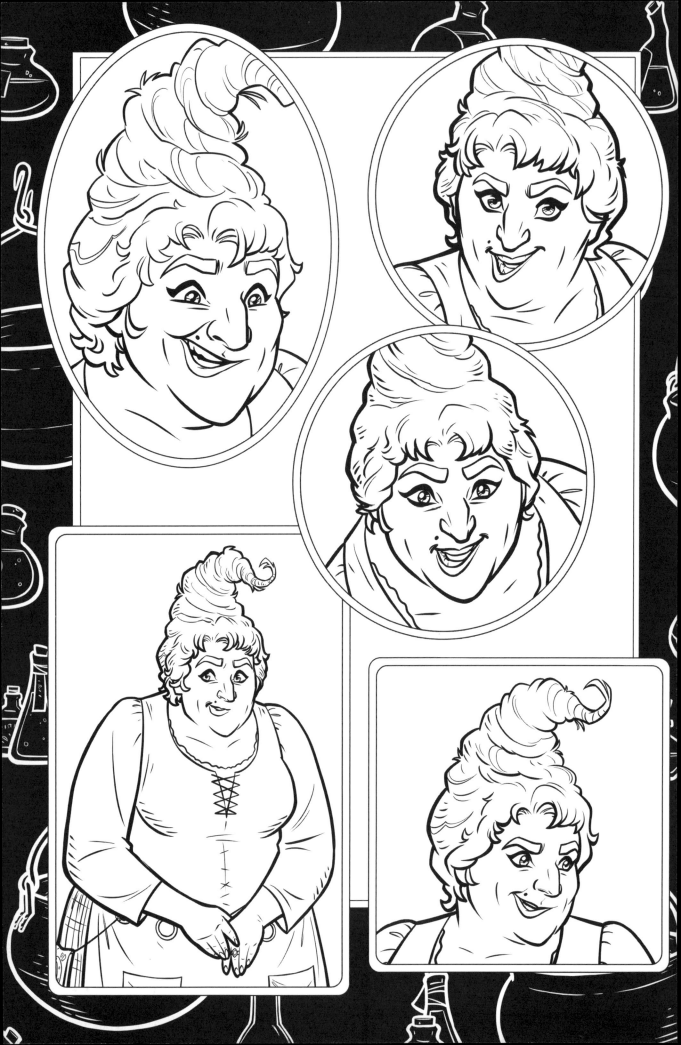

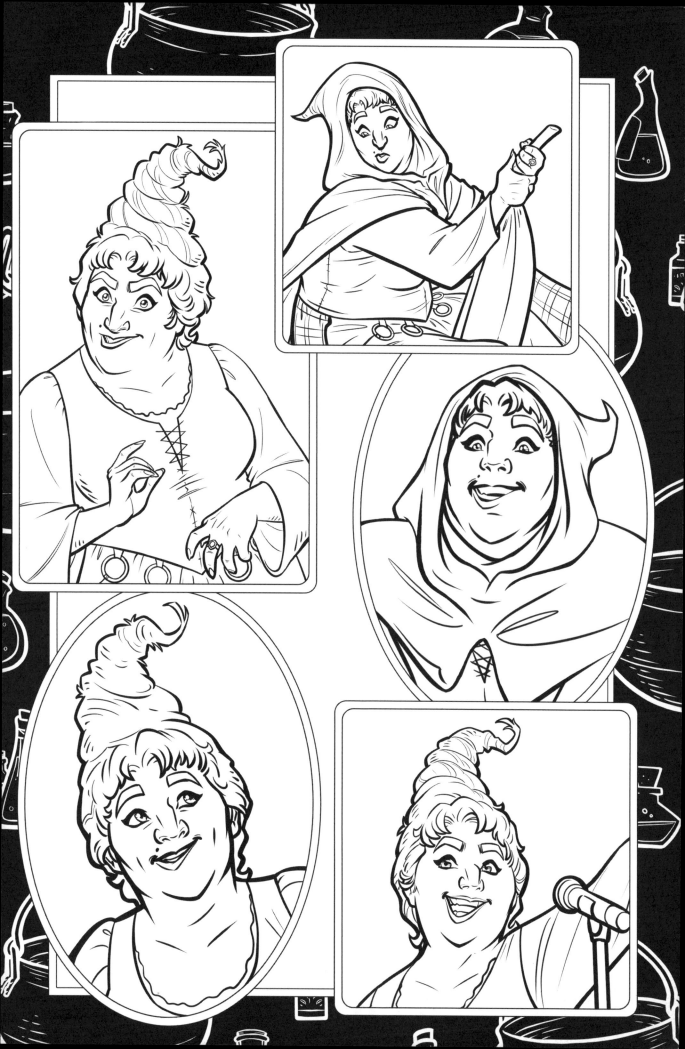

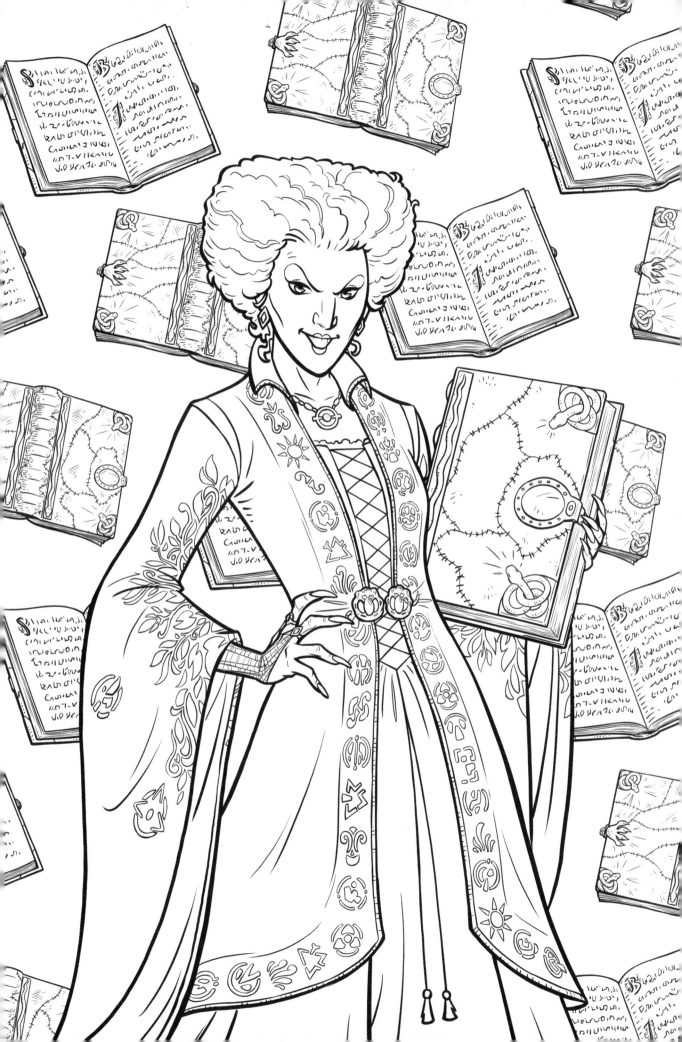

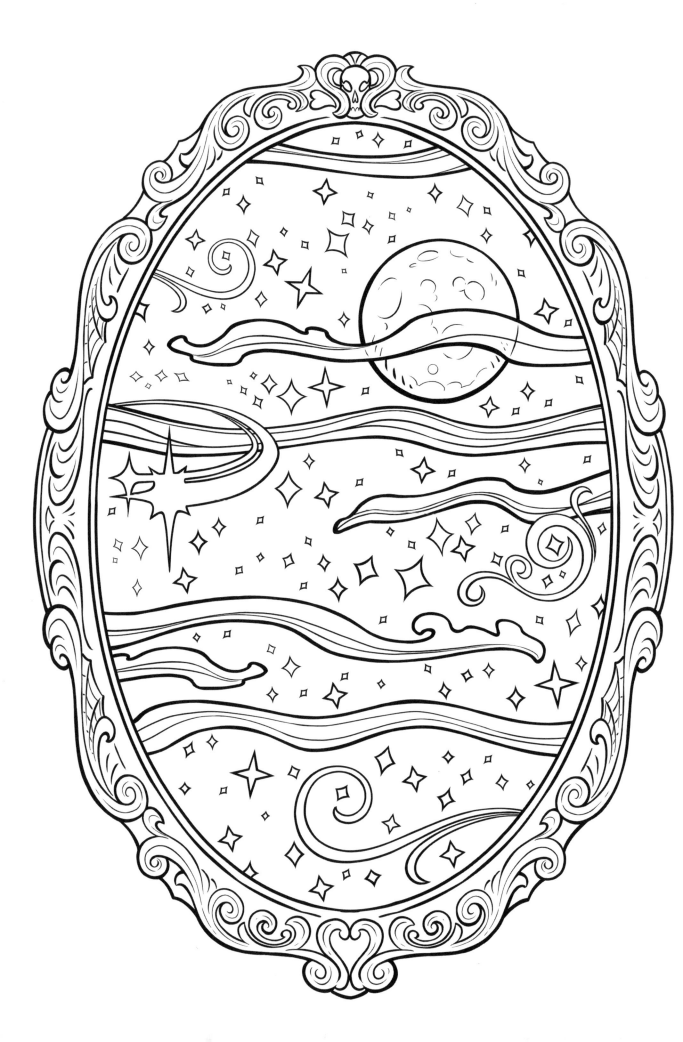

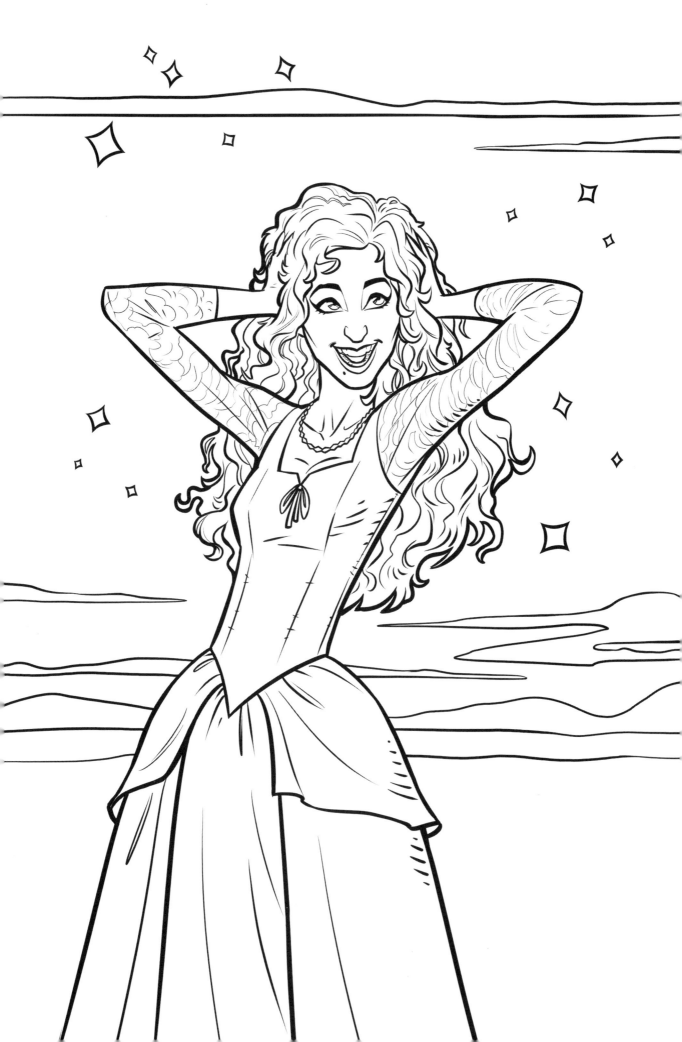

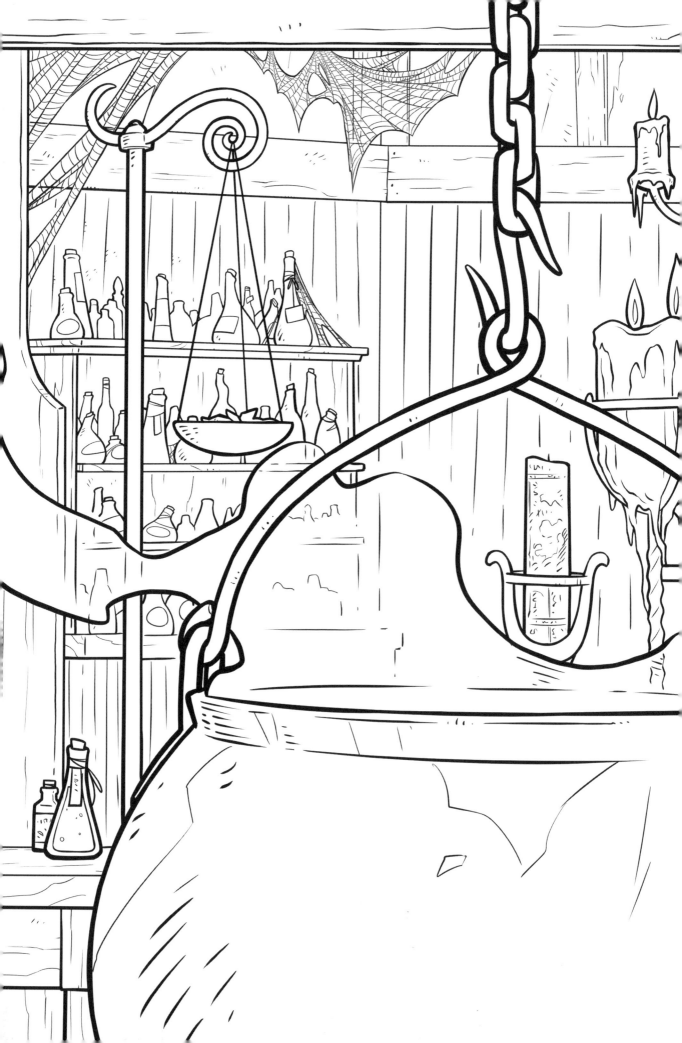

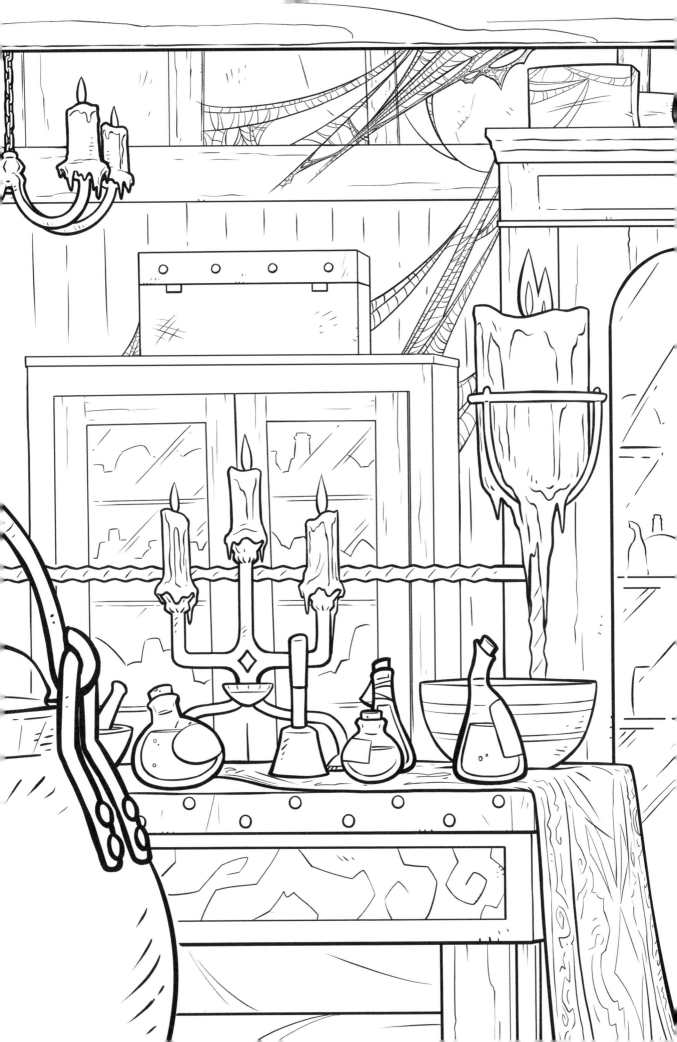

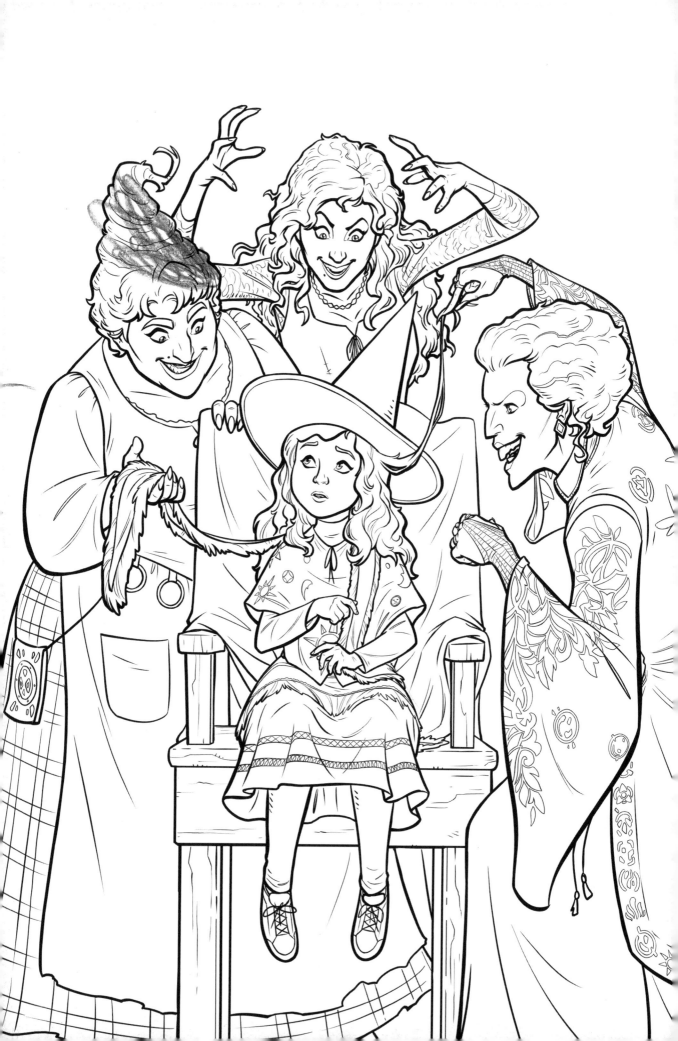

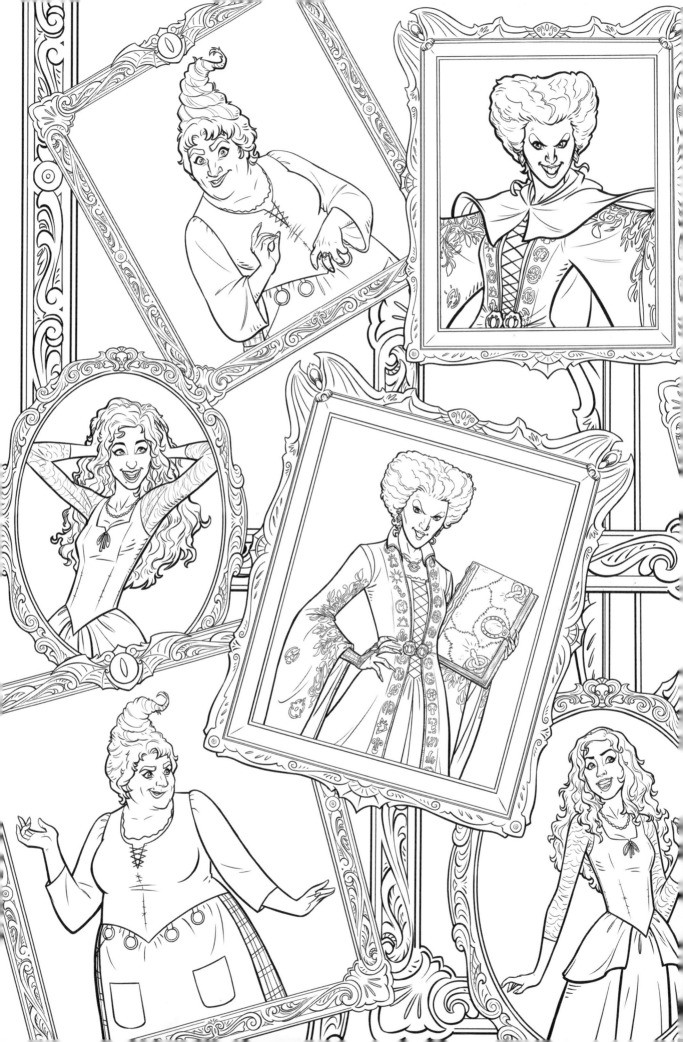

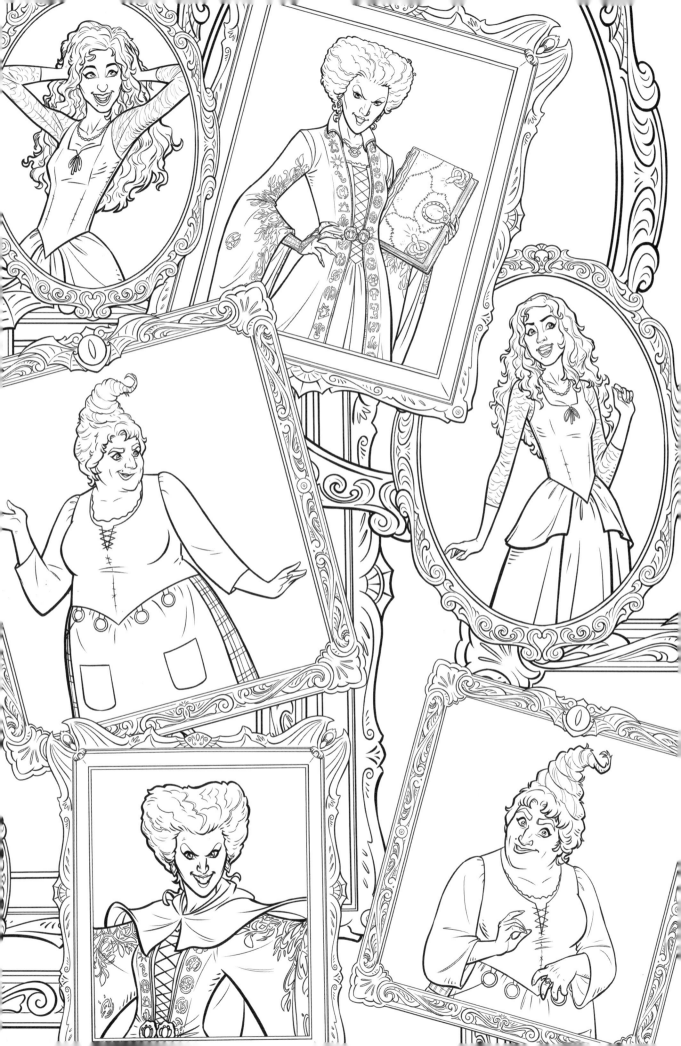

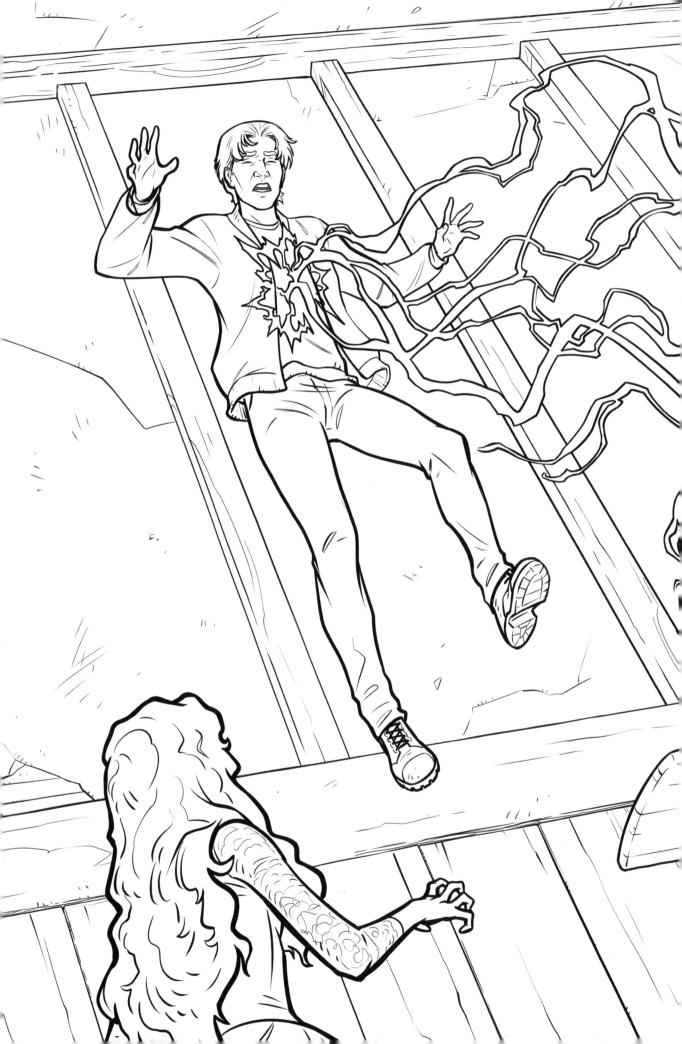

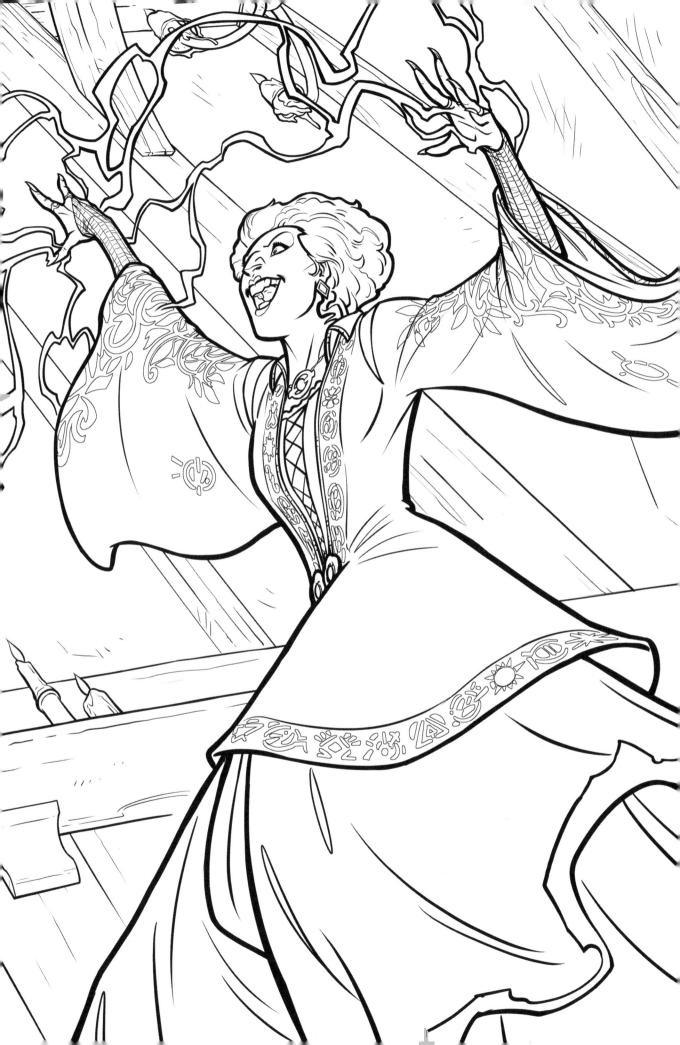

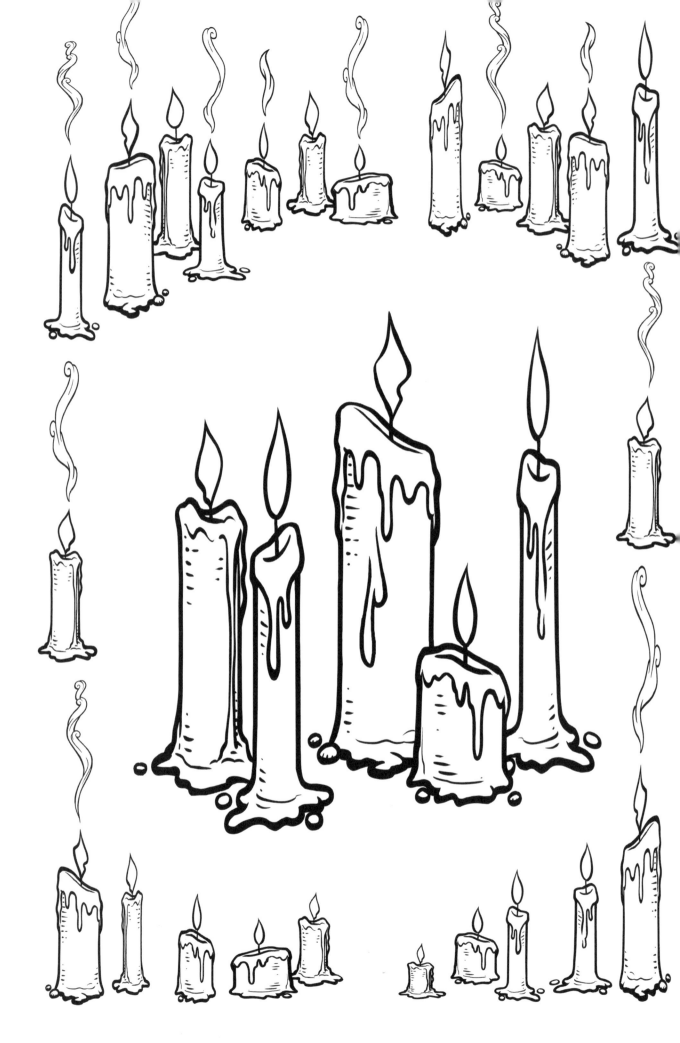

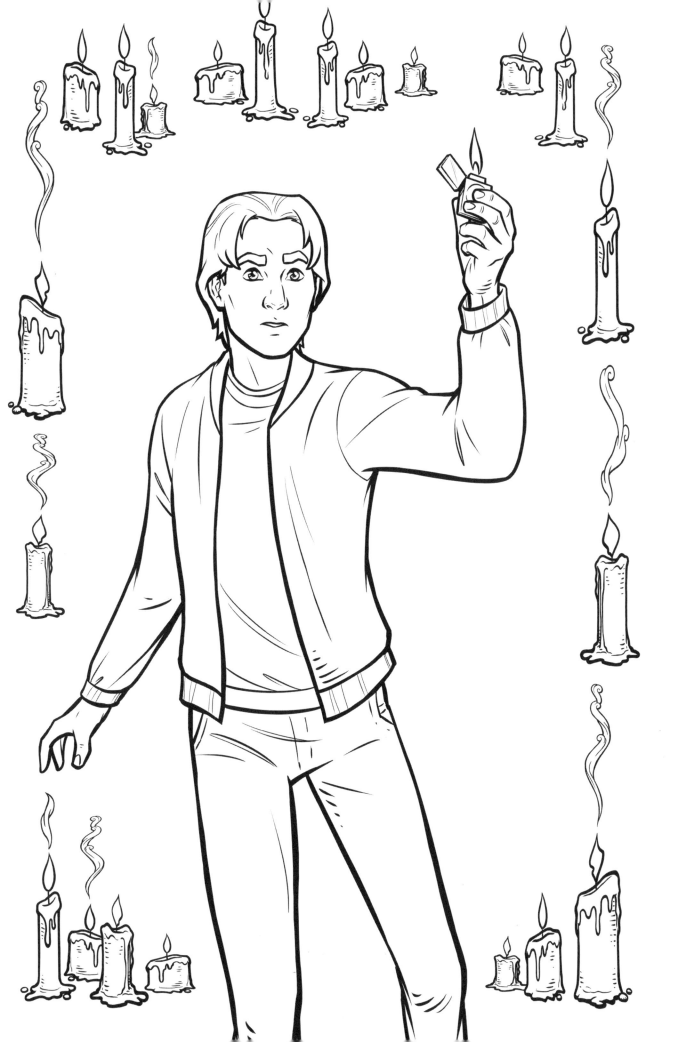

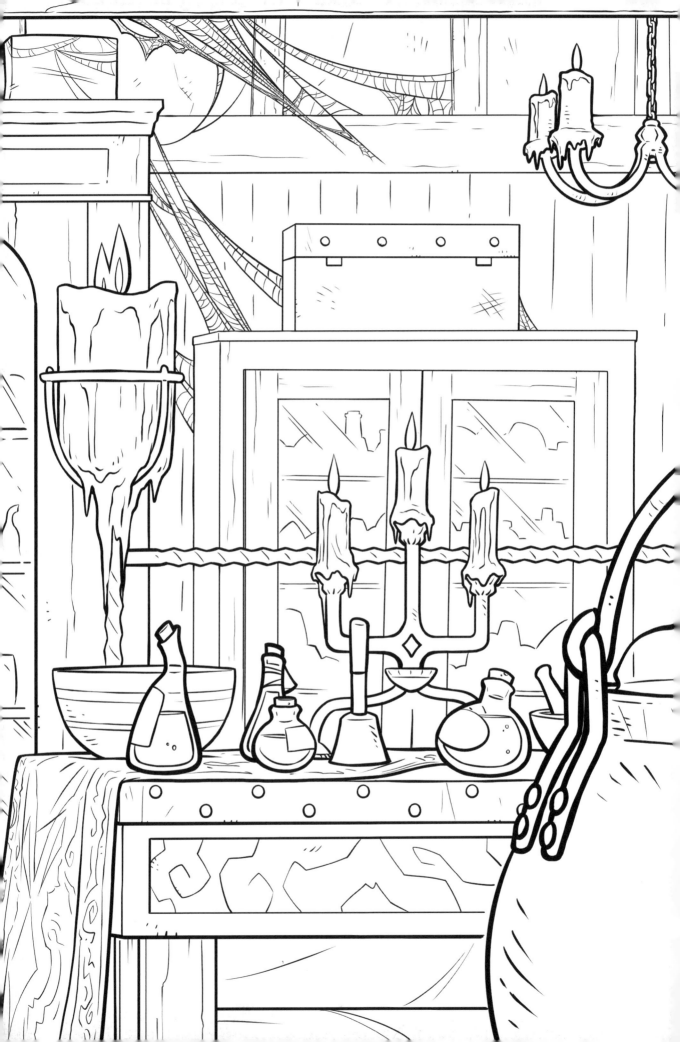

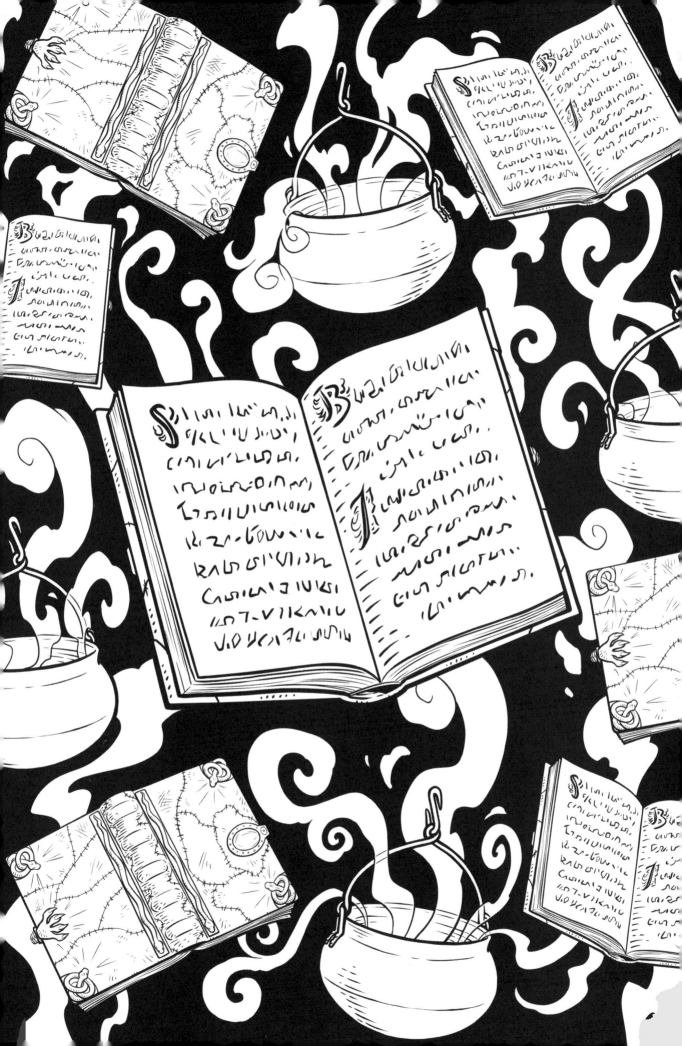

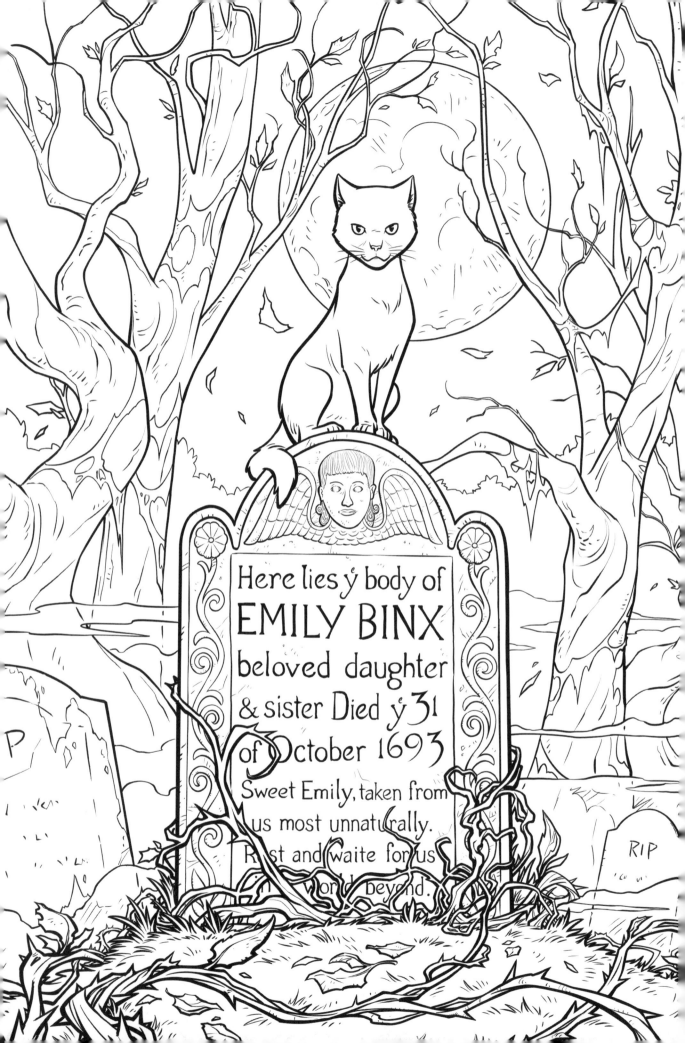

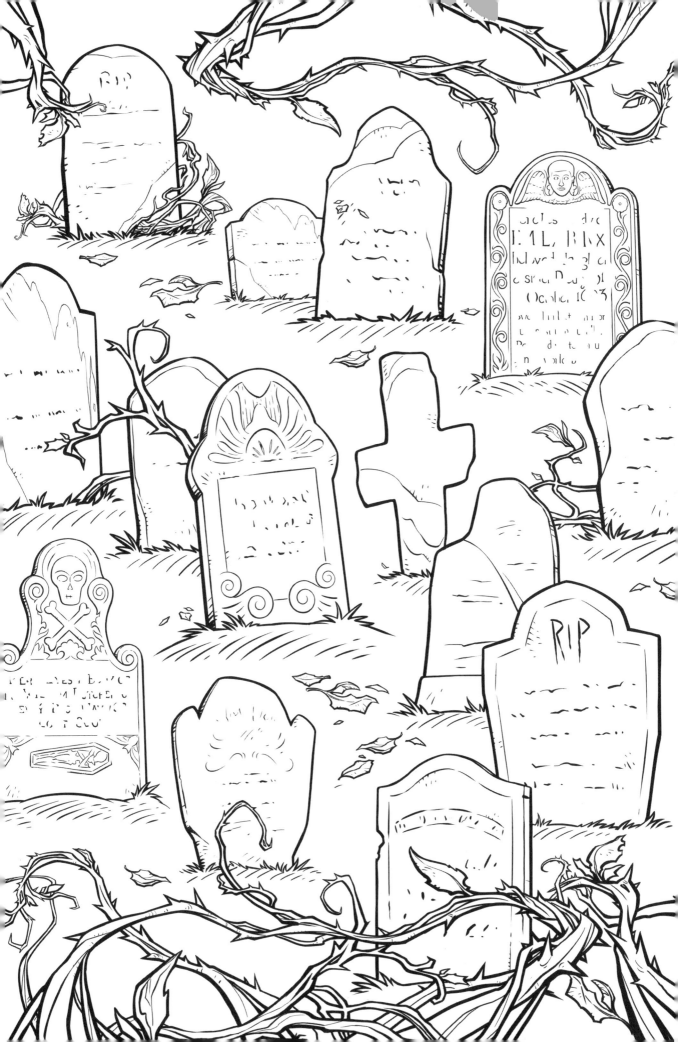

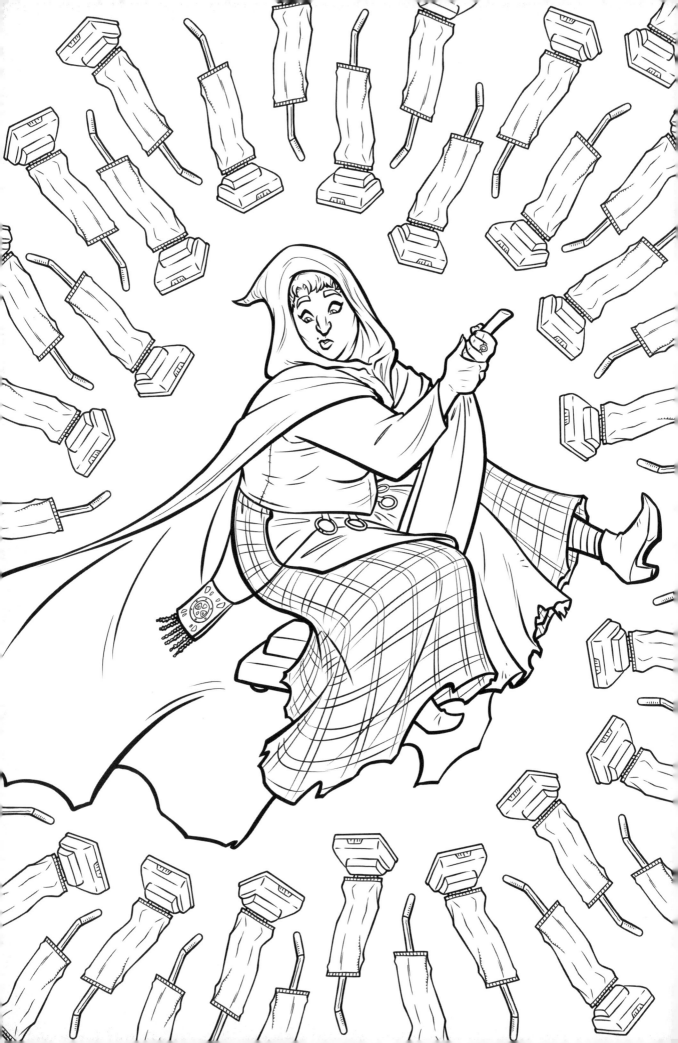

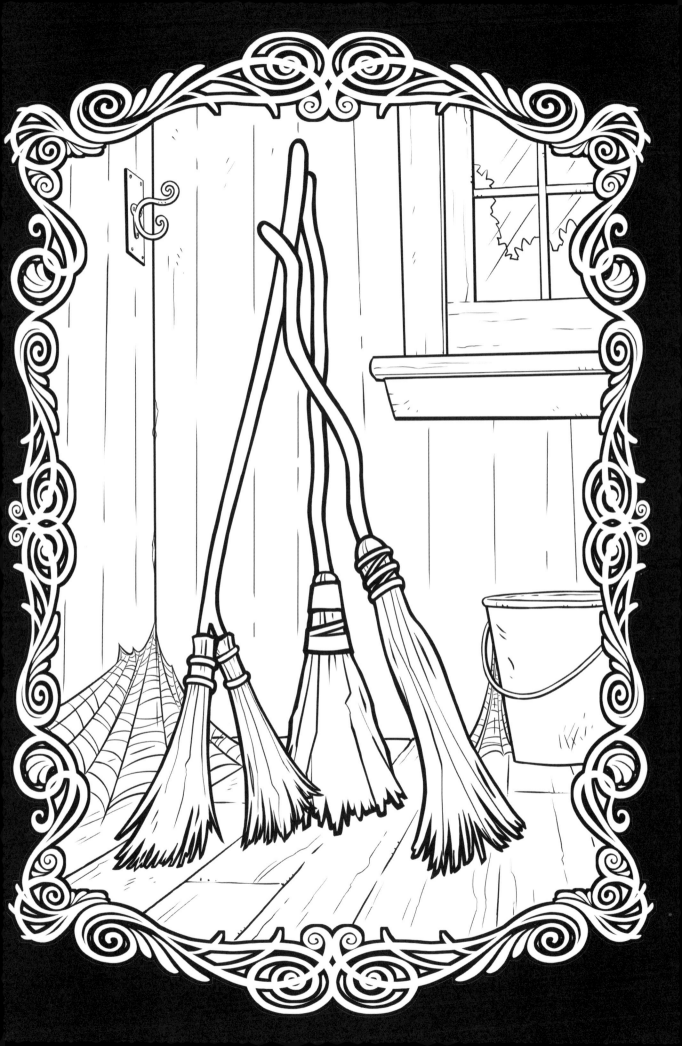

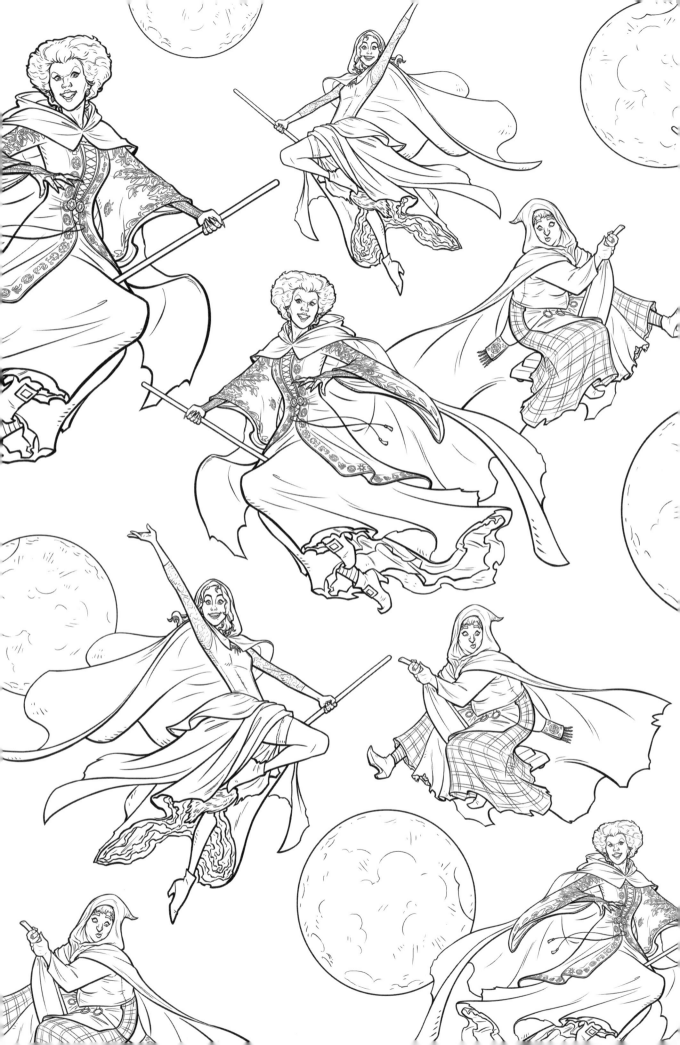

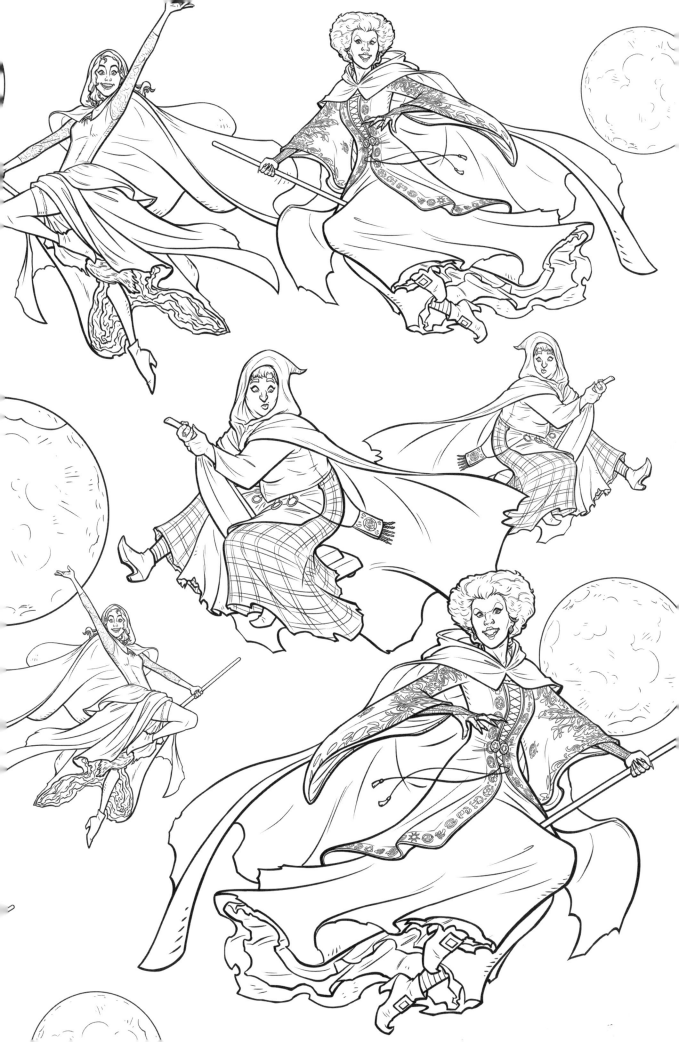

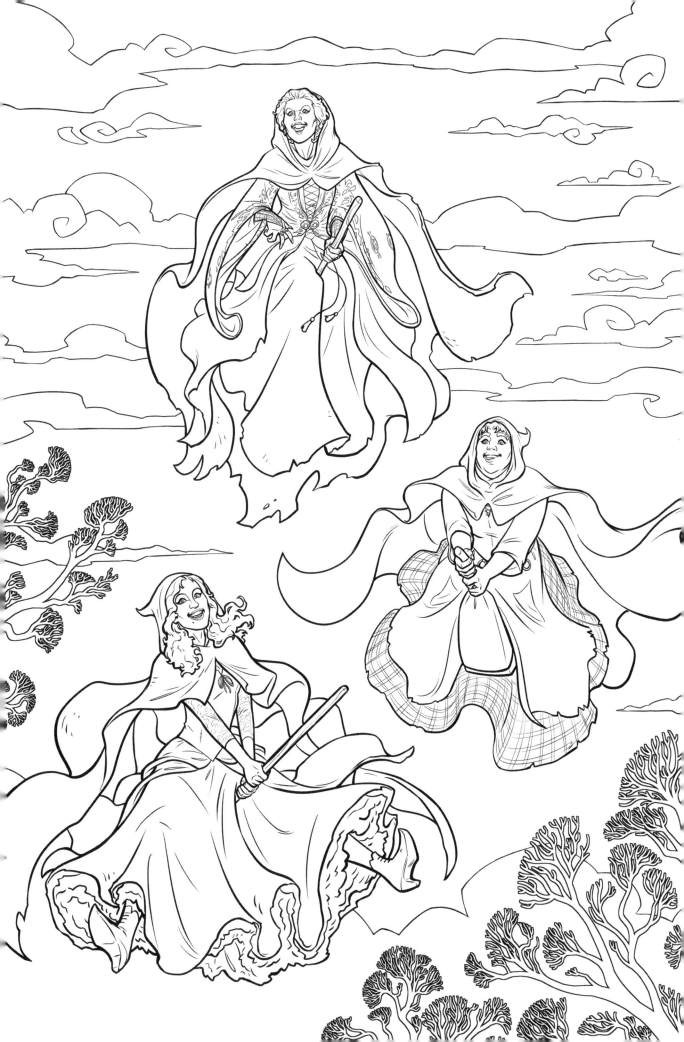

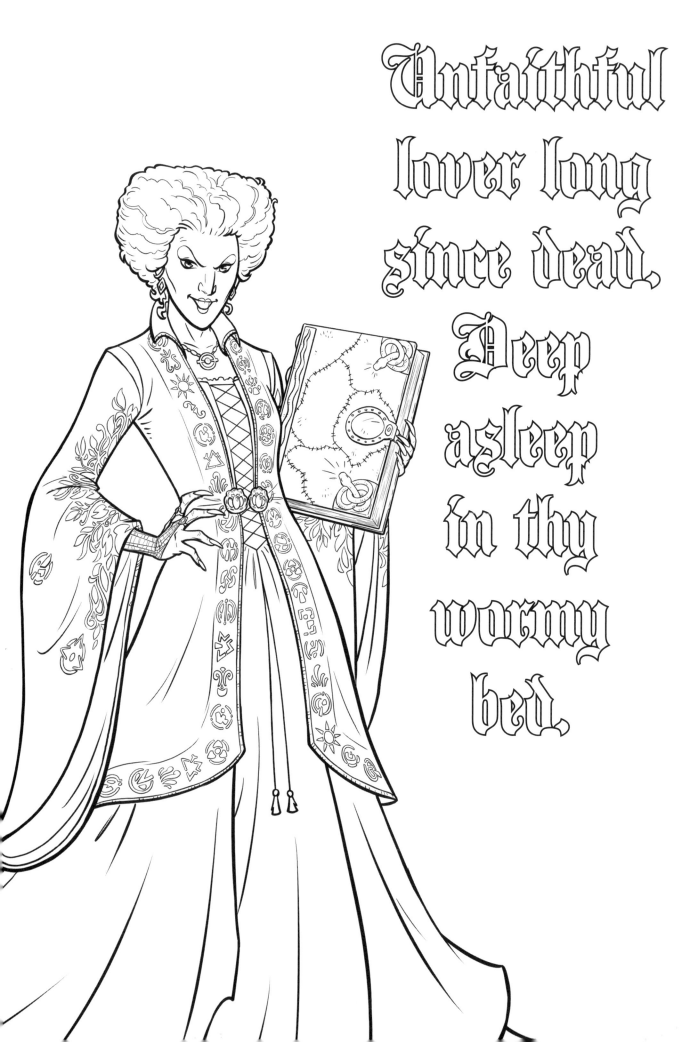

Unfaithful lover long since dead. Deep asleep in thy wormy bed.

Wiggle thy toes, open thine eyes, twist thy fingers toward the sky. Life is sweet, be not shy. On thy feet. So sayeth I!

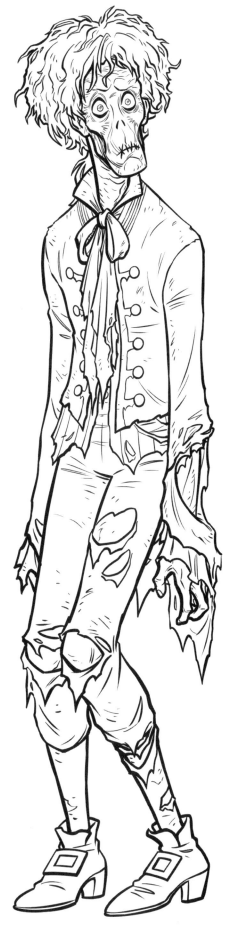

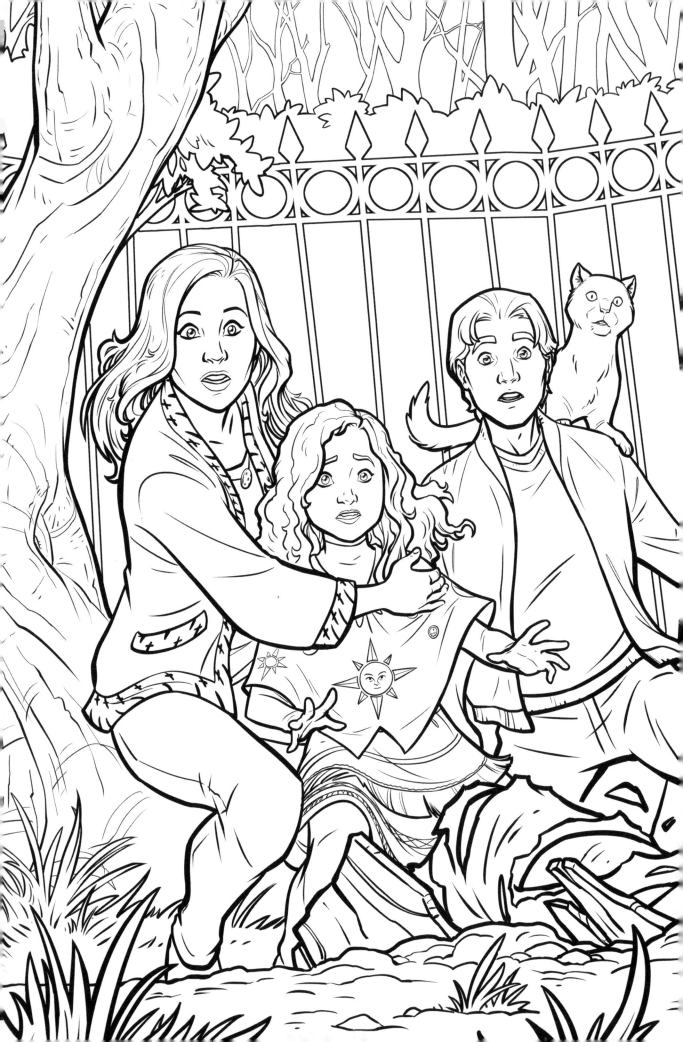

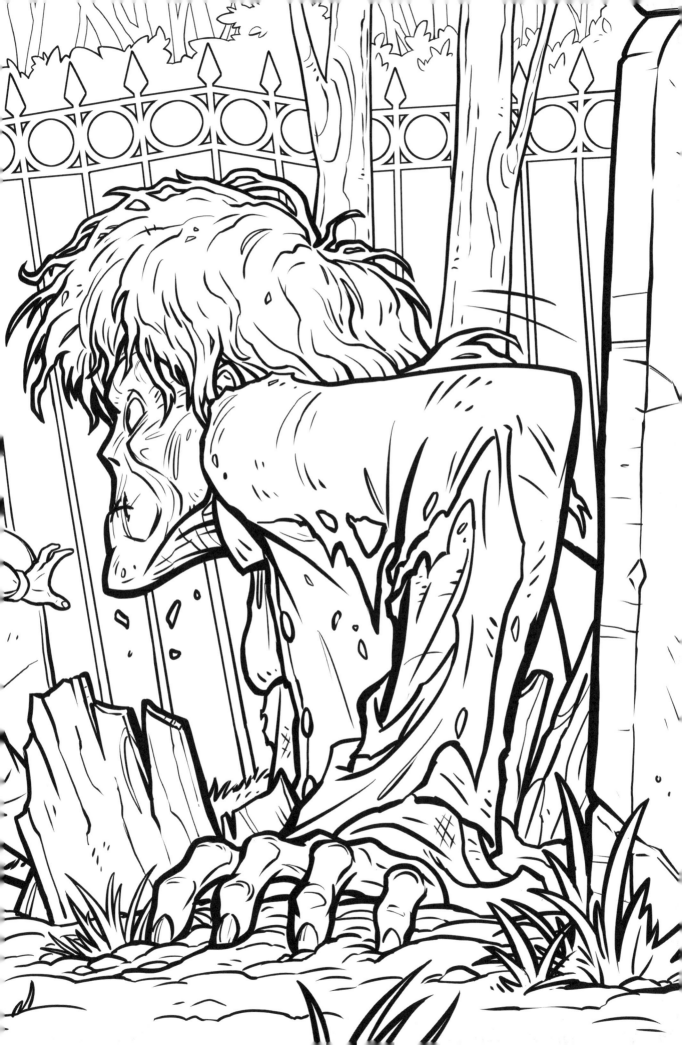

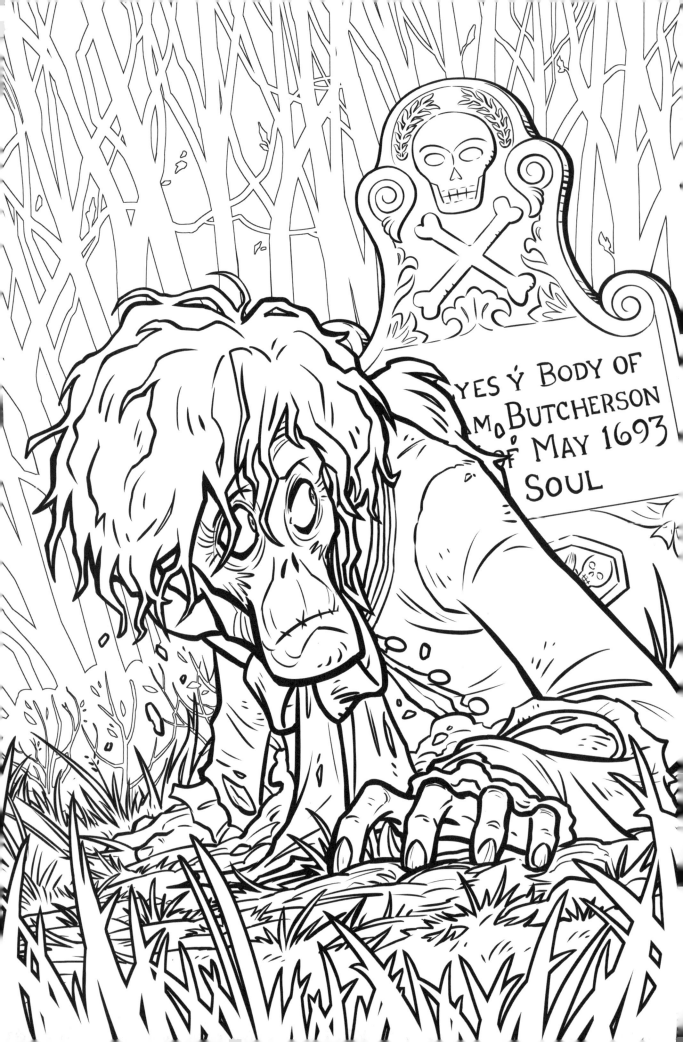

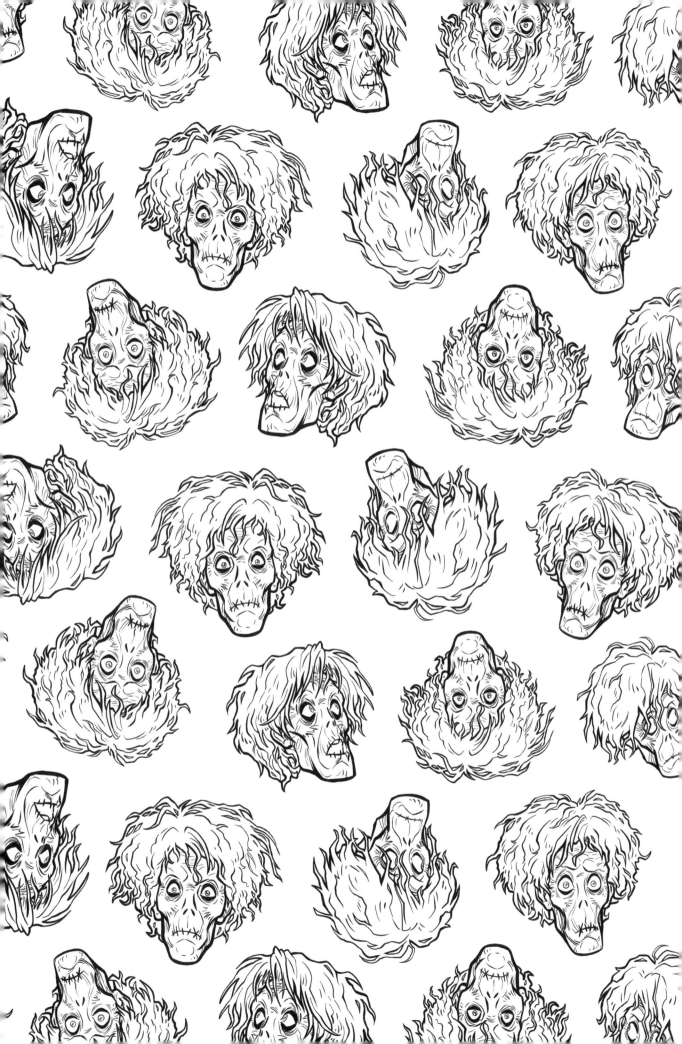

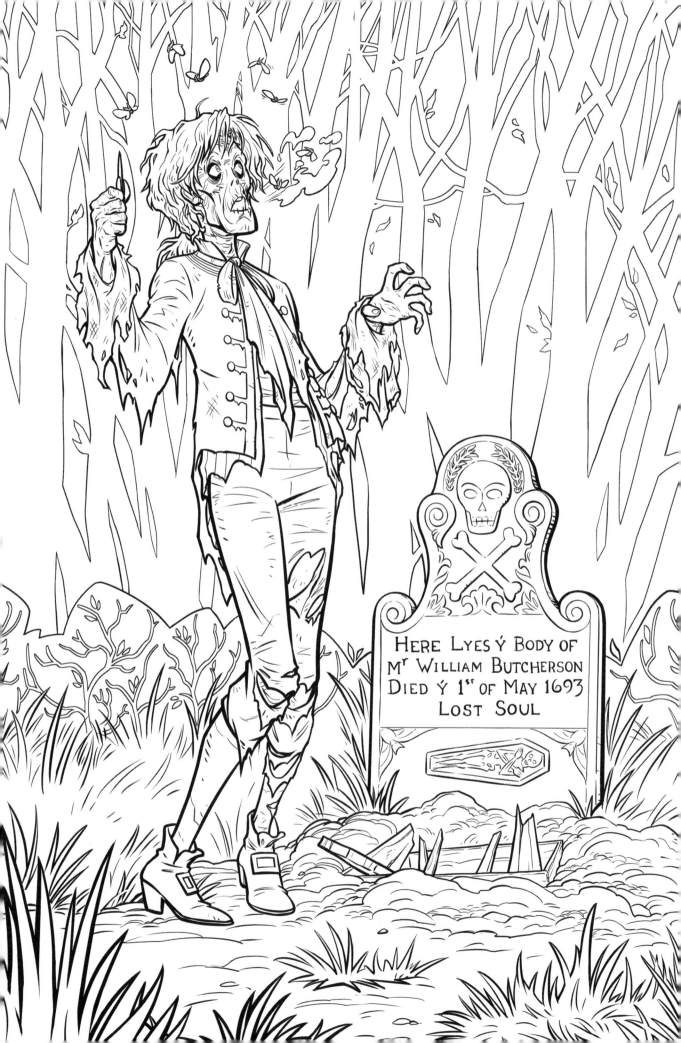

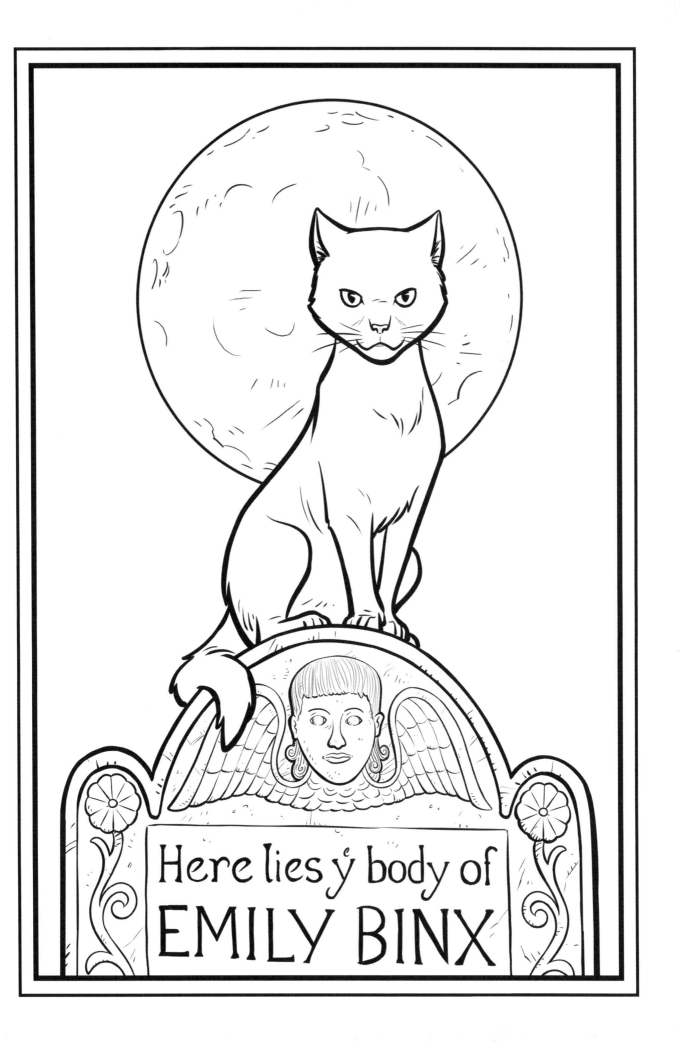

Here lies ỹ body of
EMILY BINX

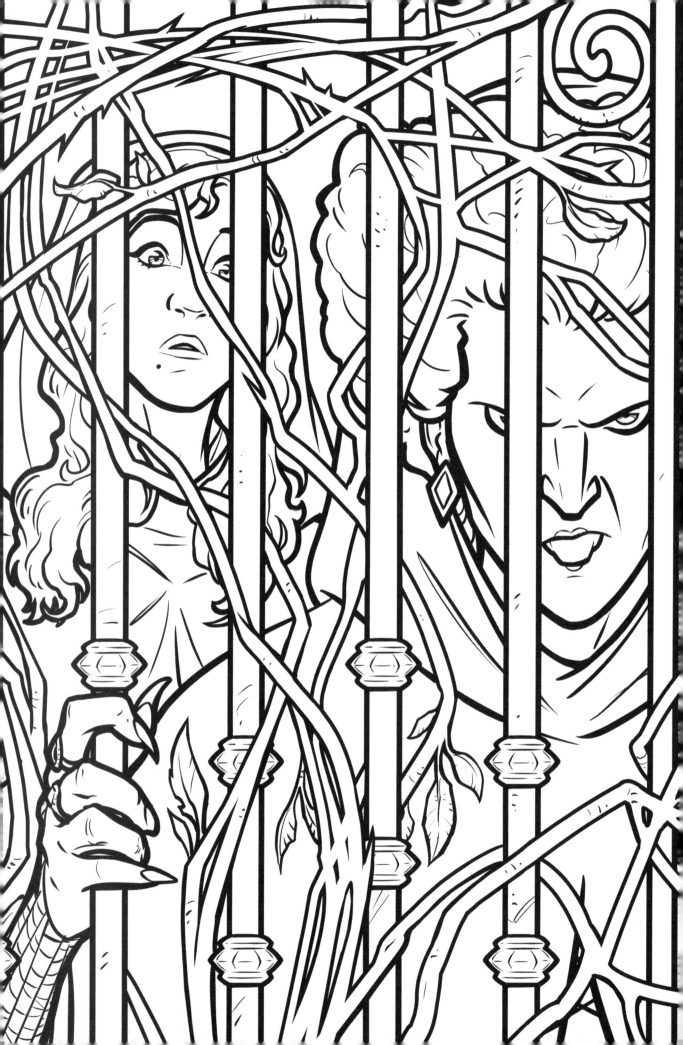

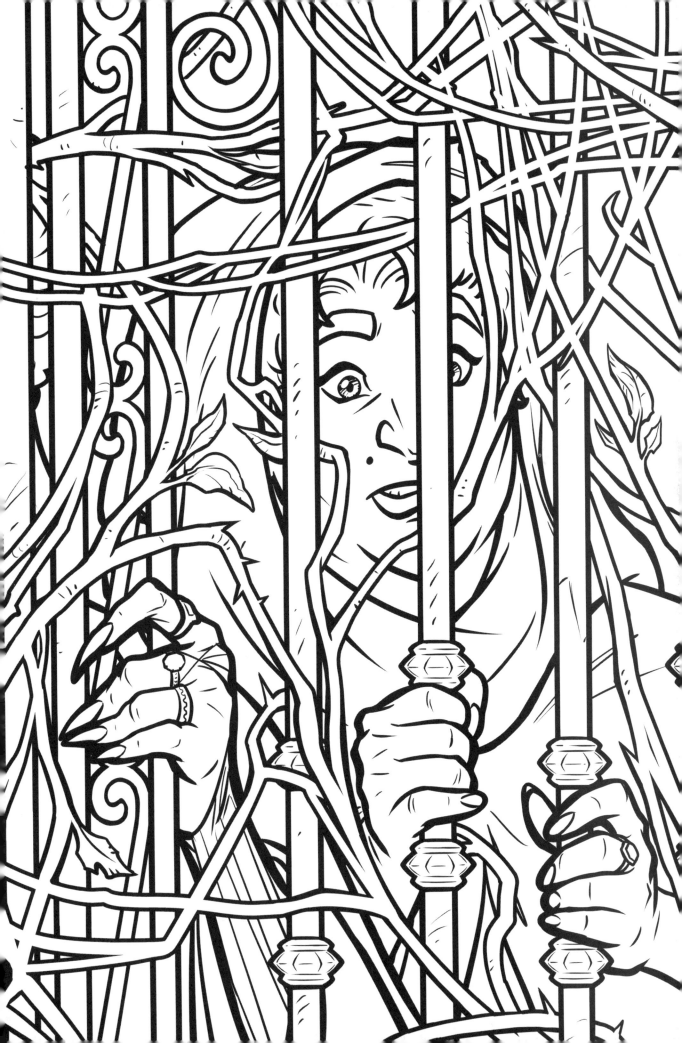

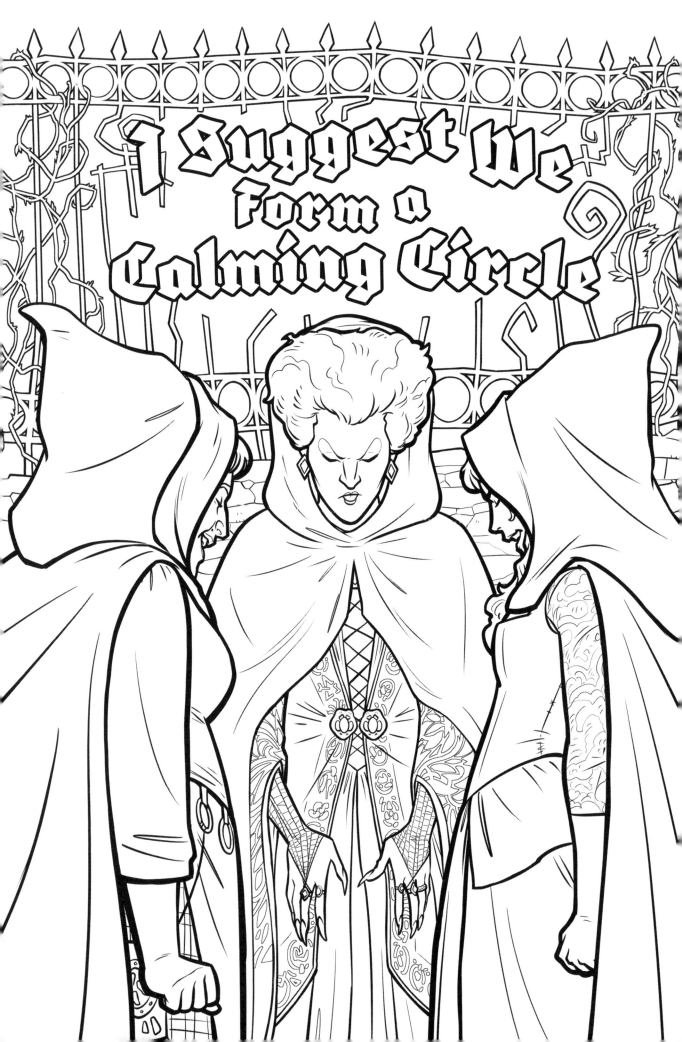

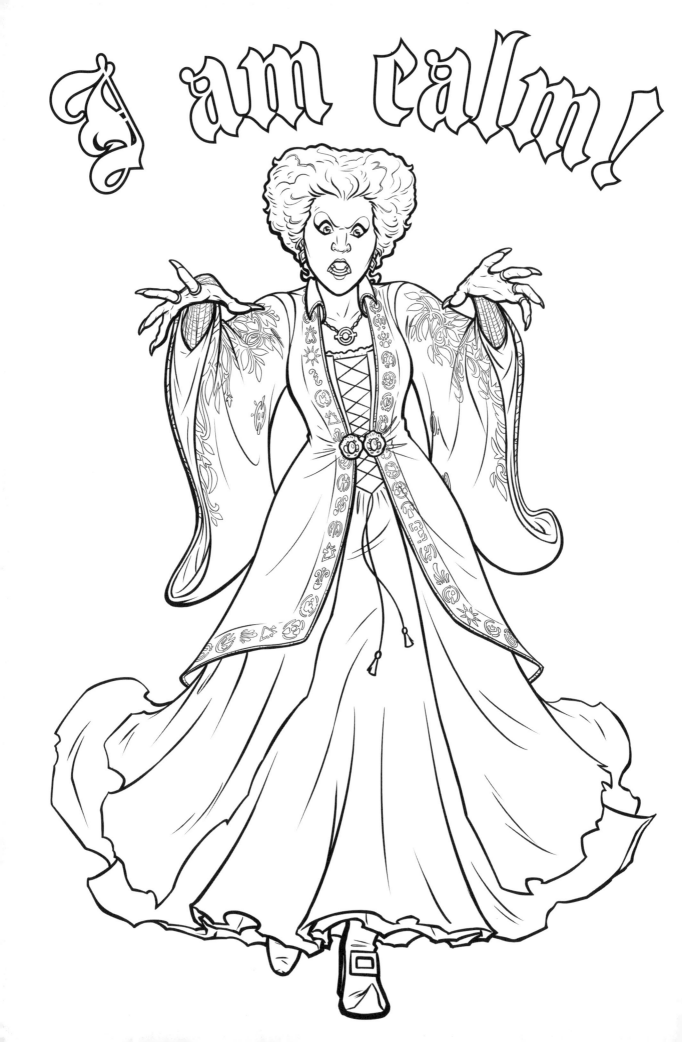

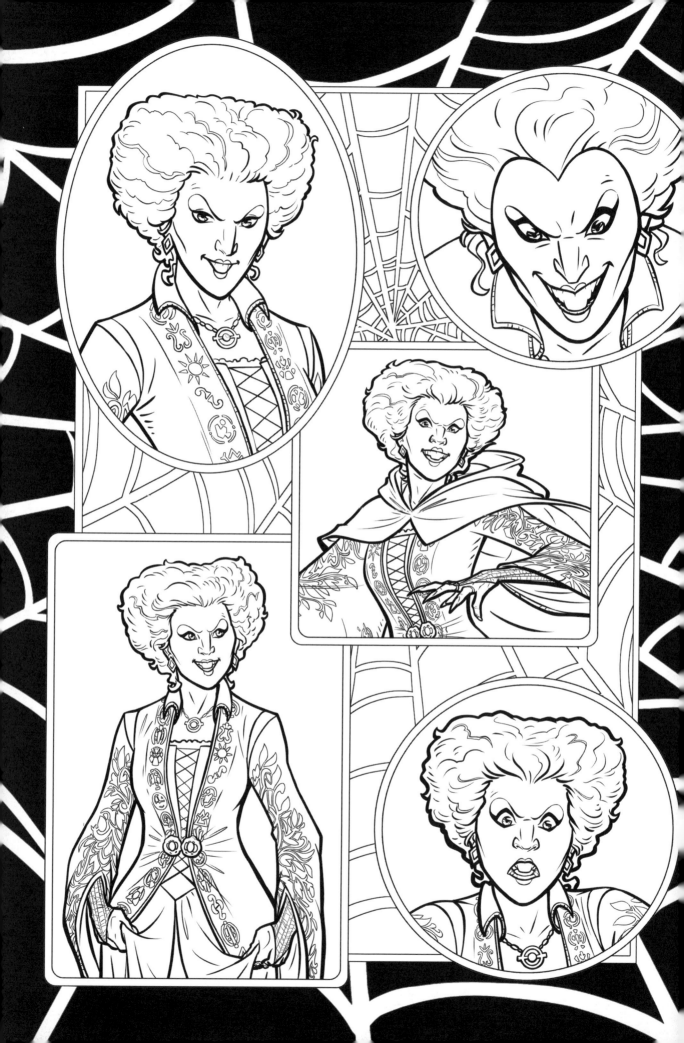

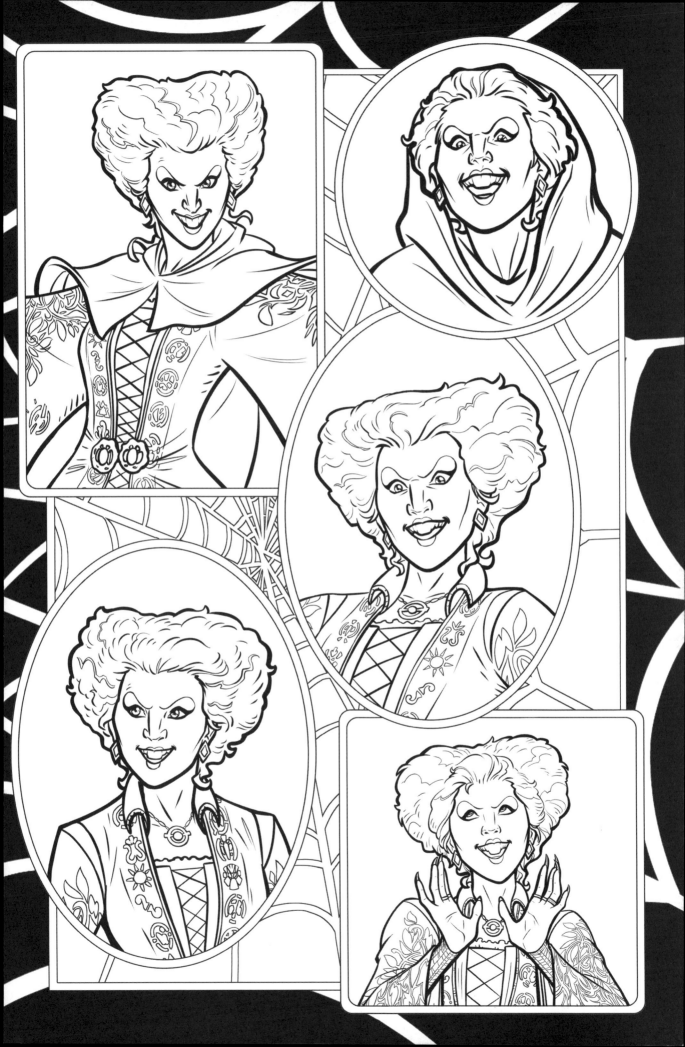

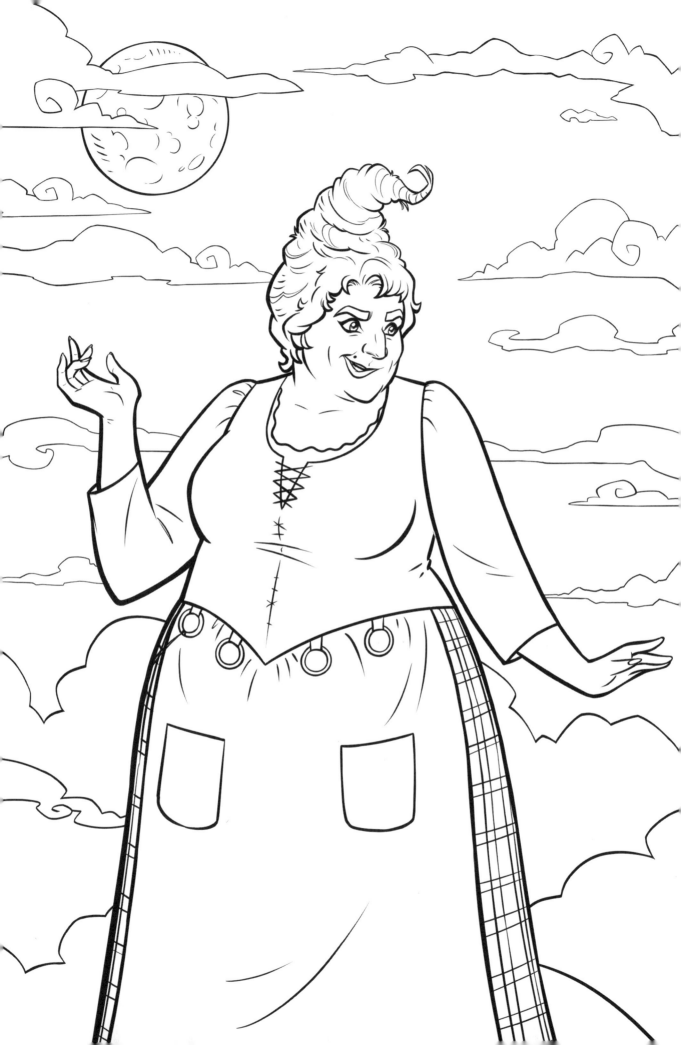

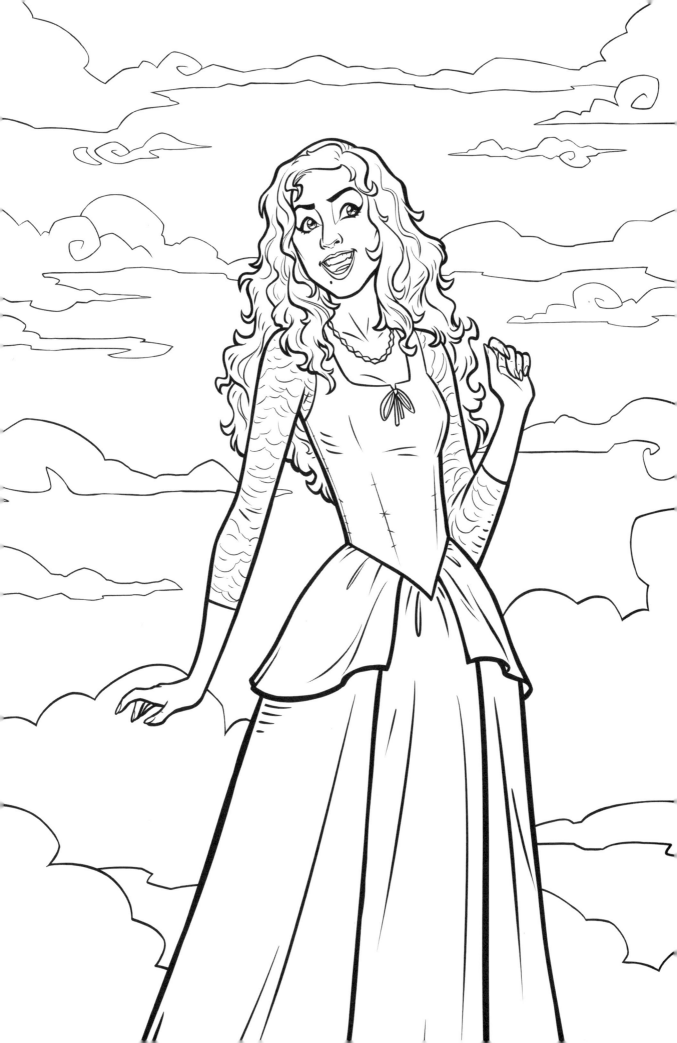

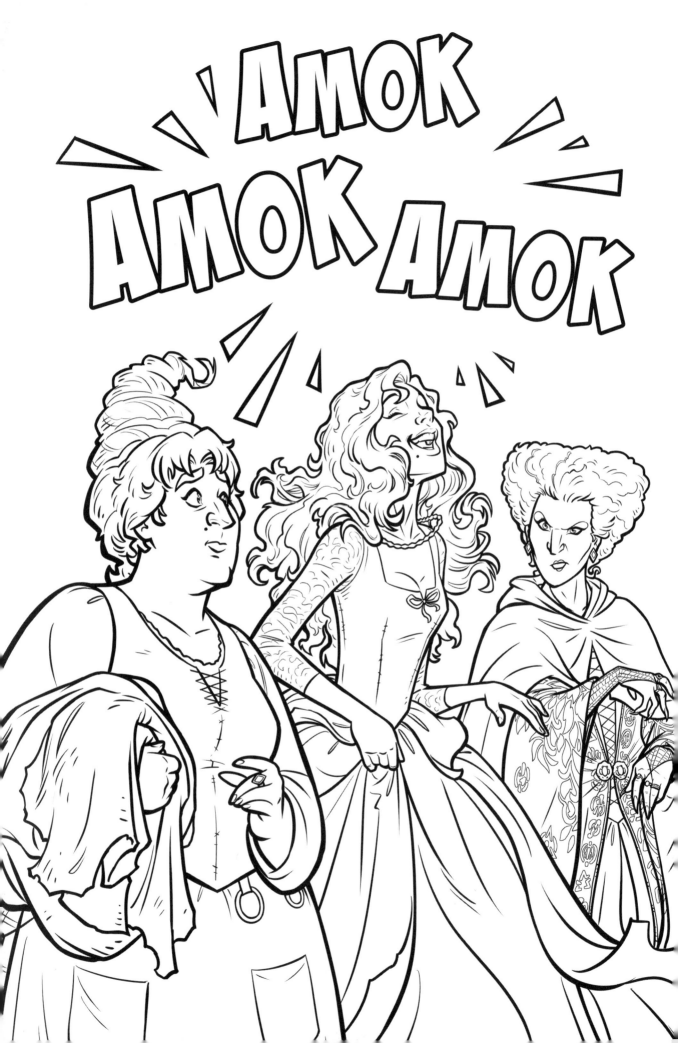

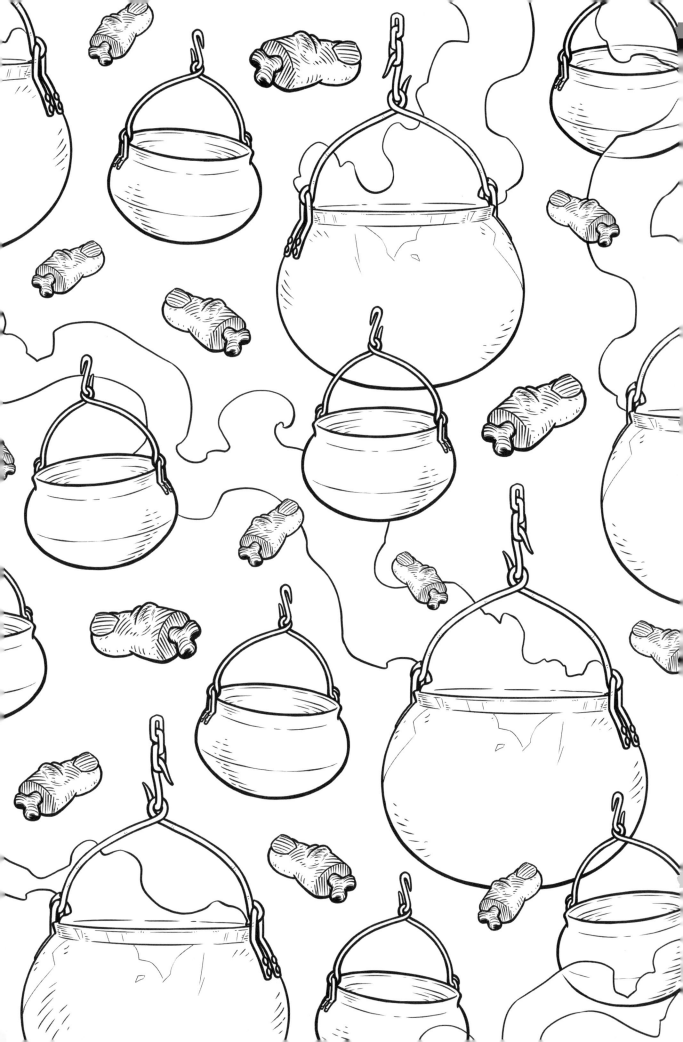

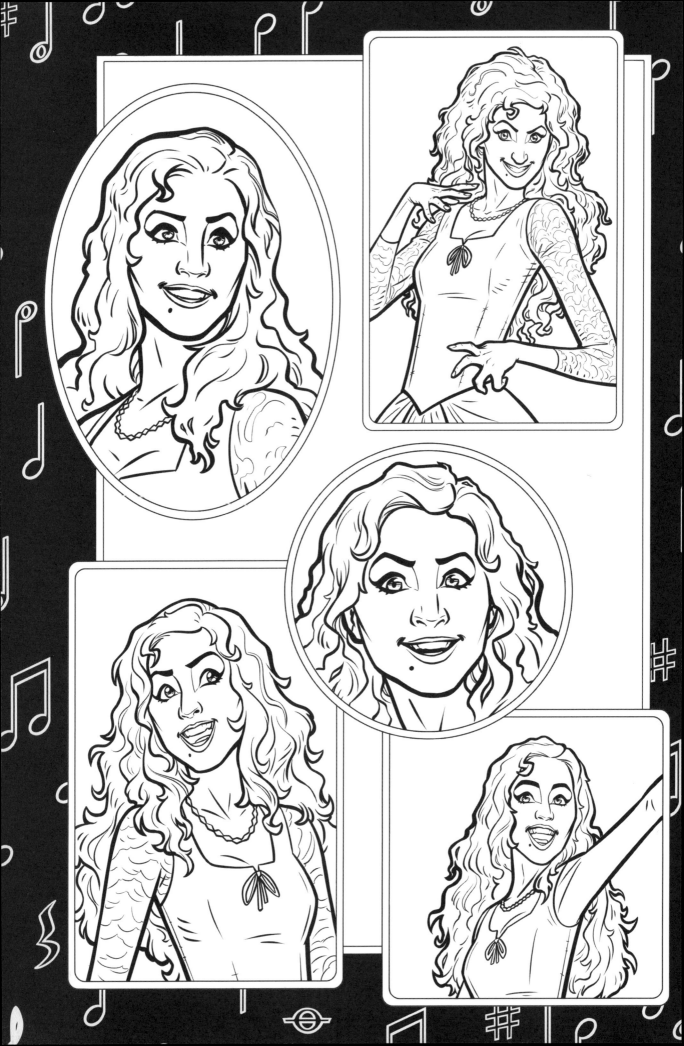

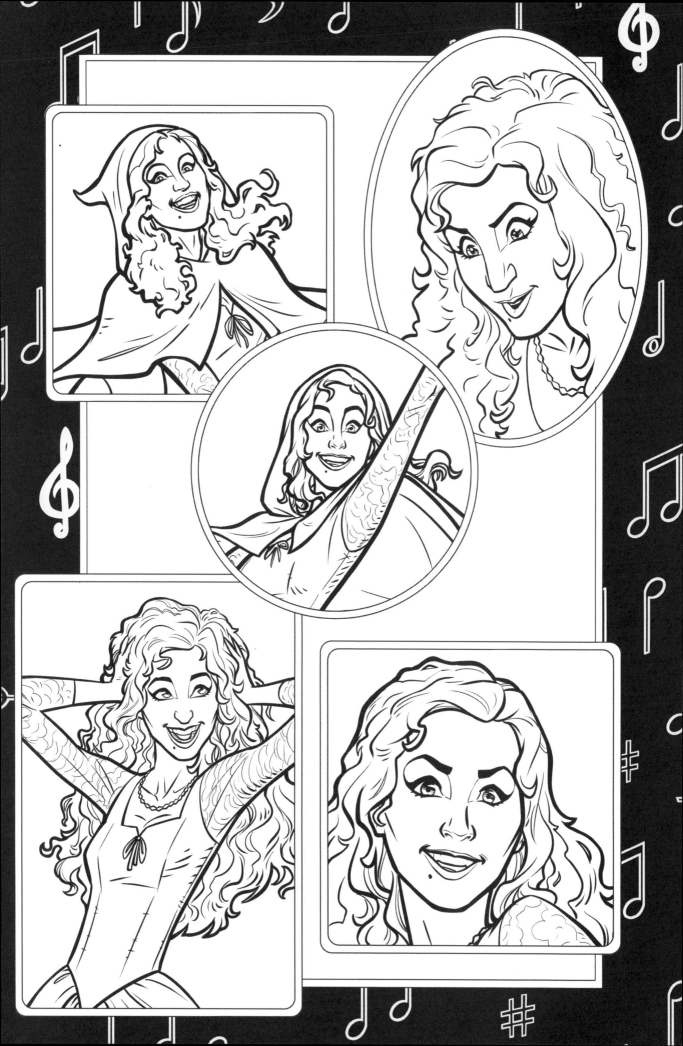

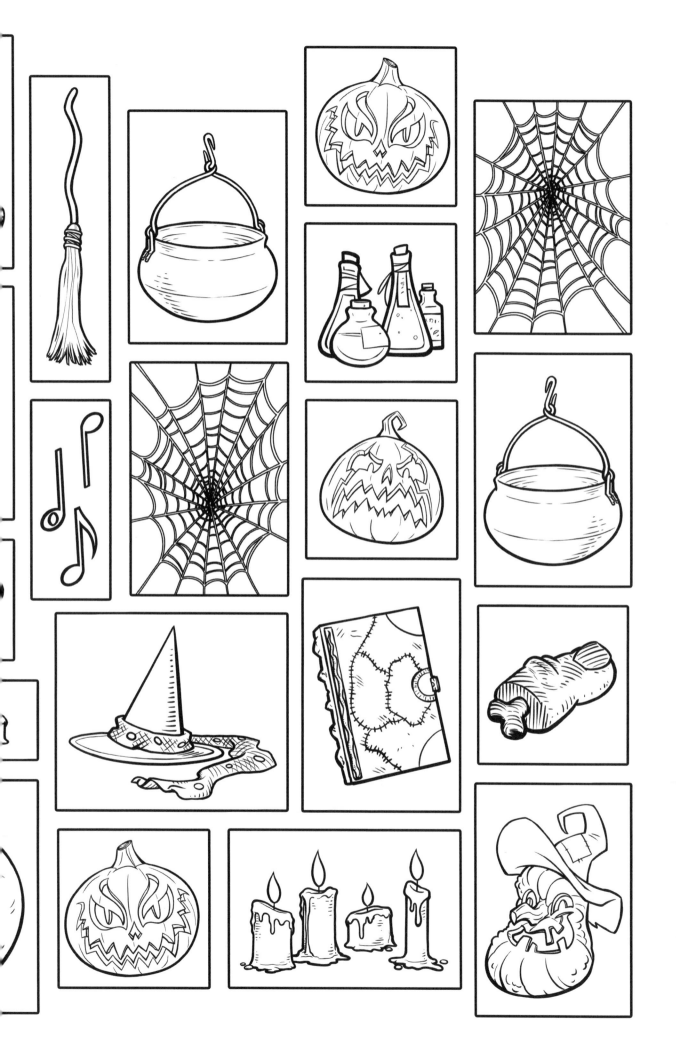

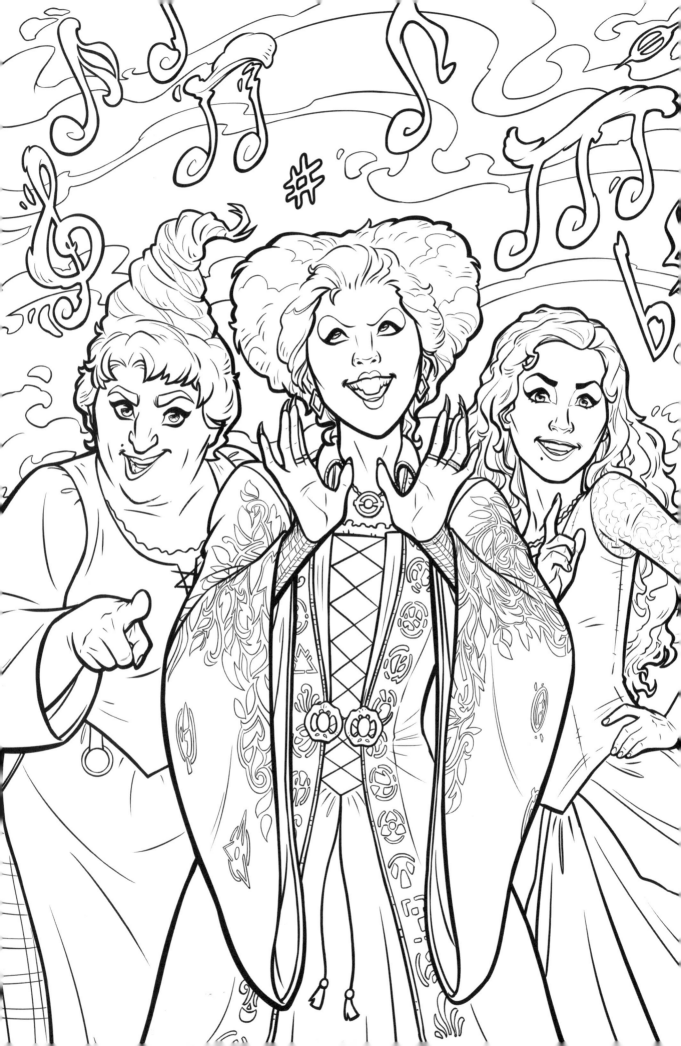

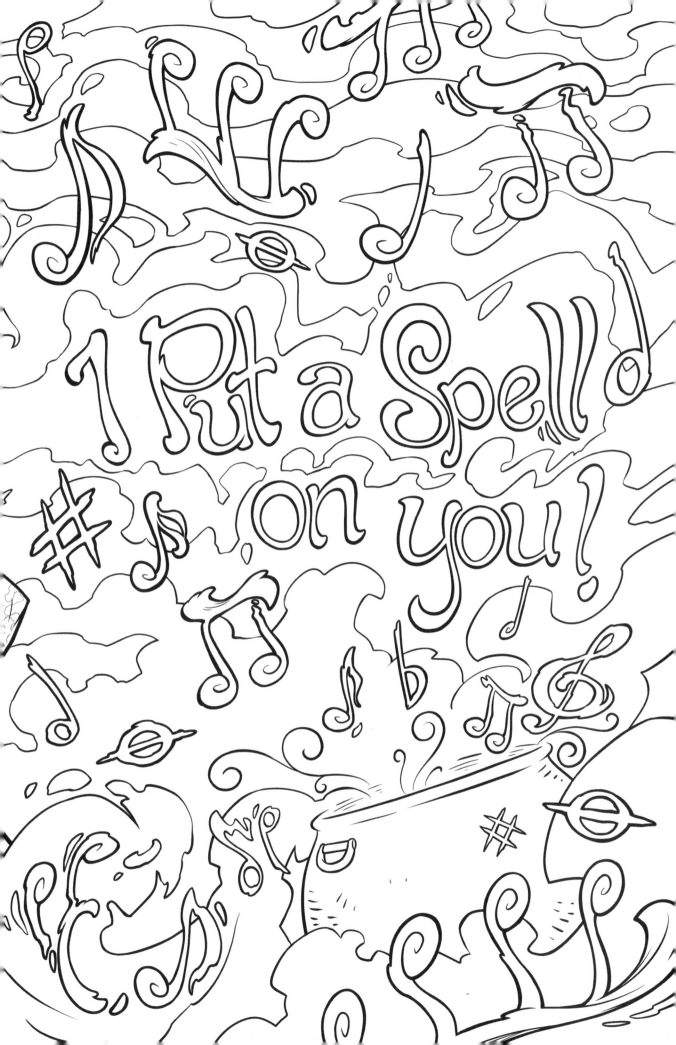

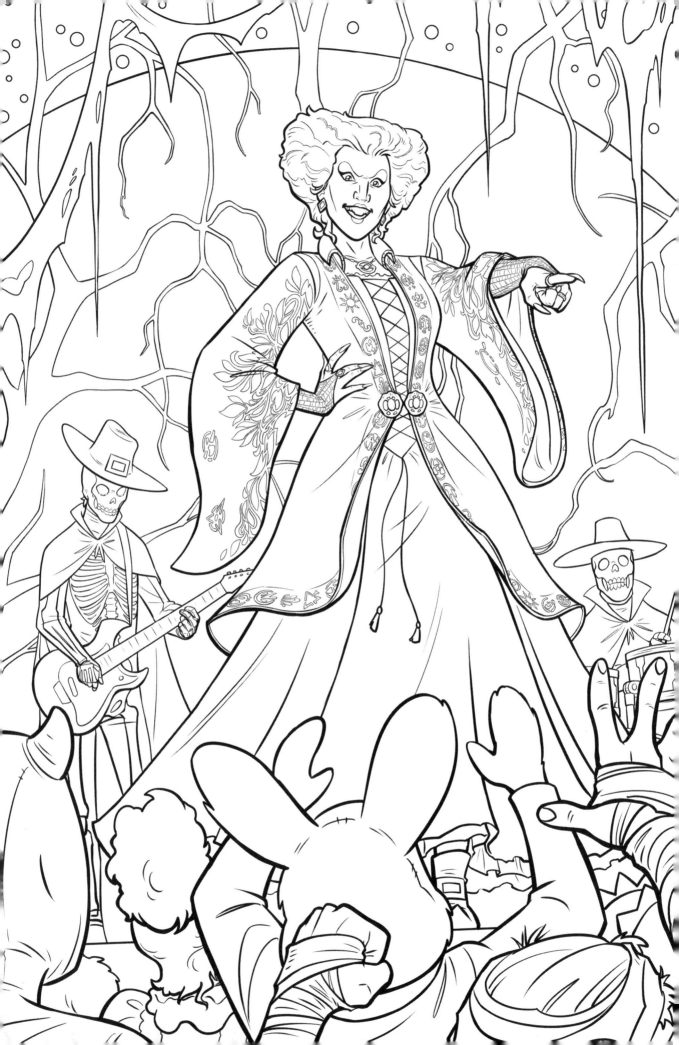

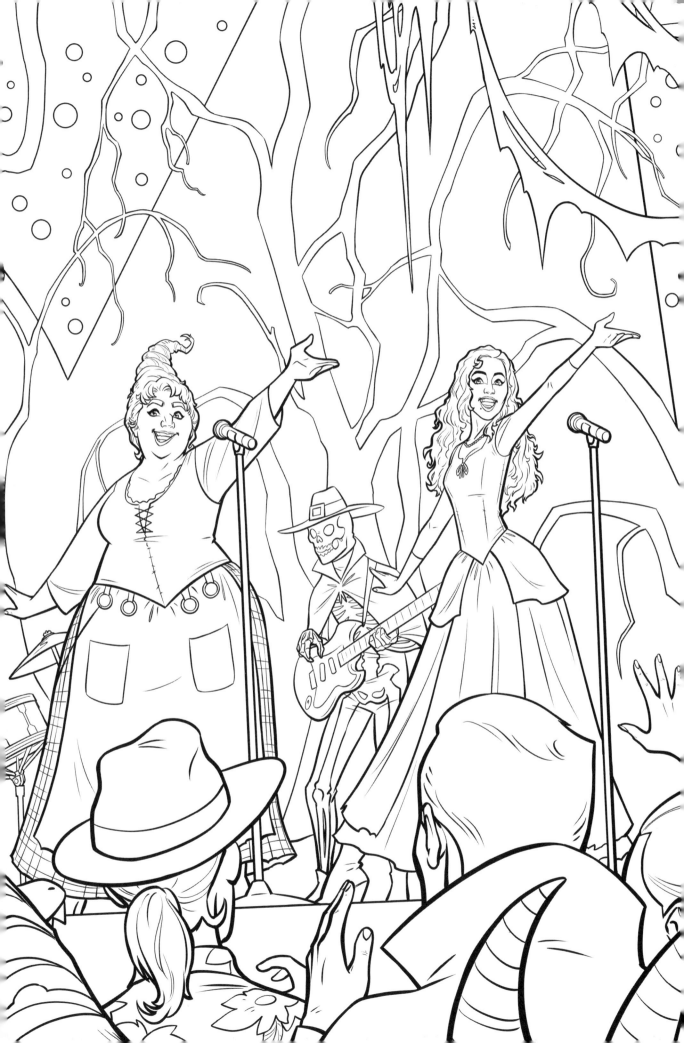

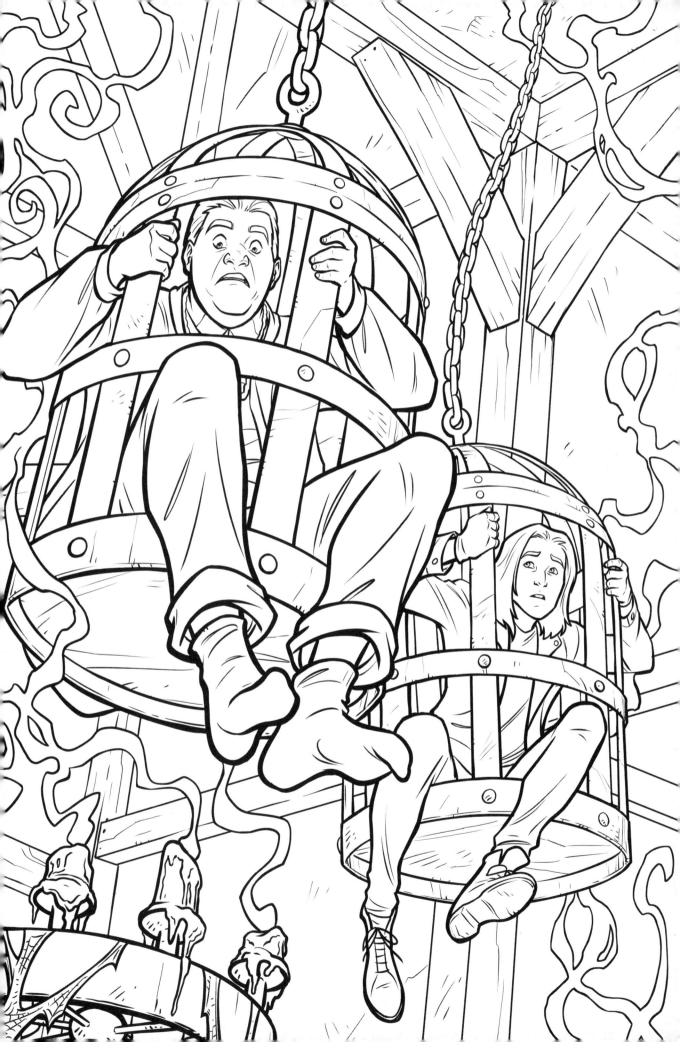

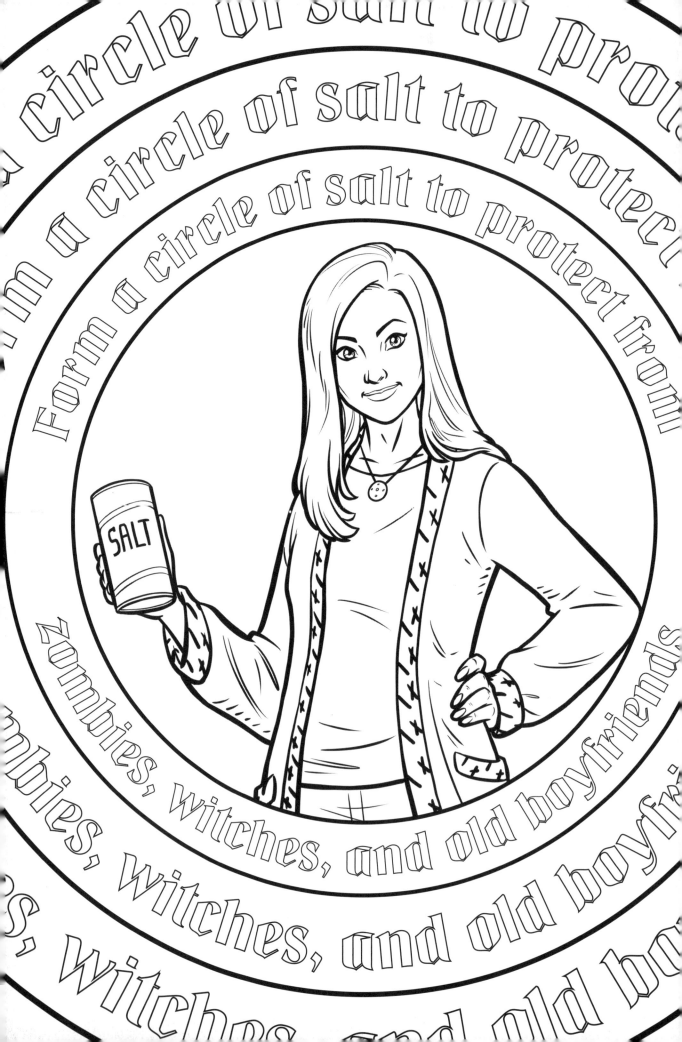

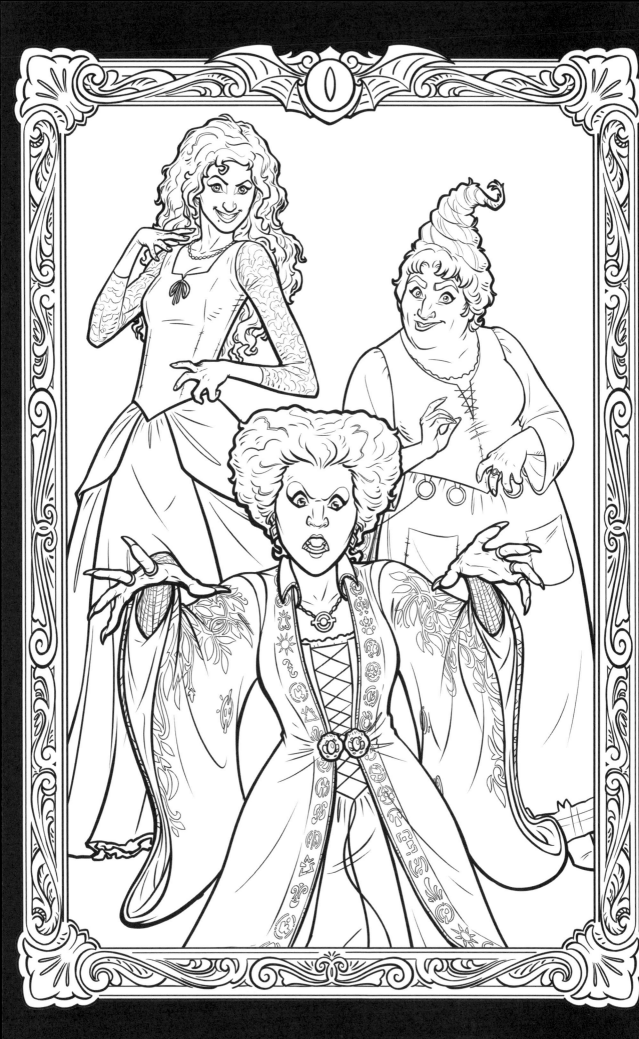

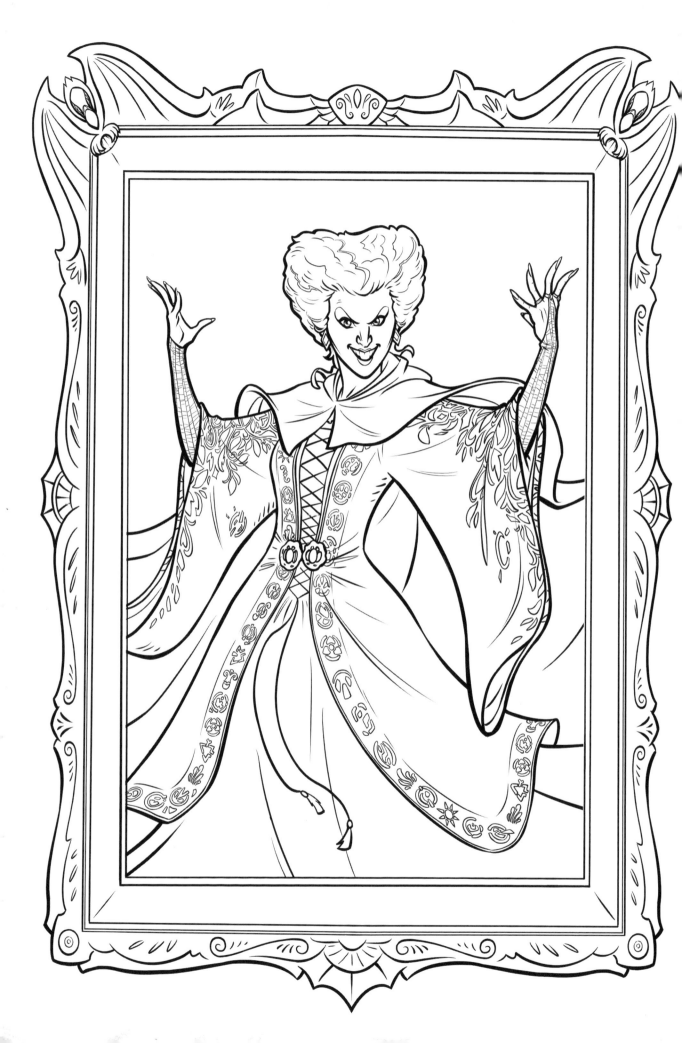

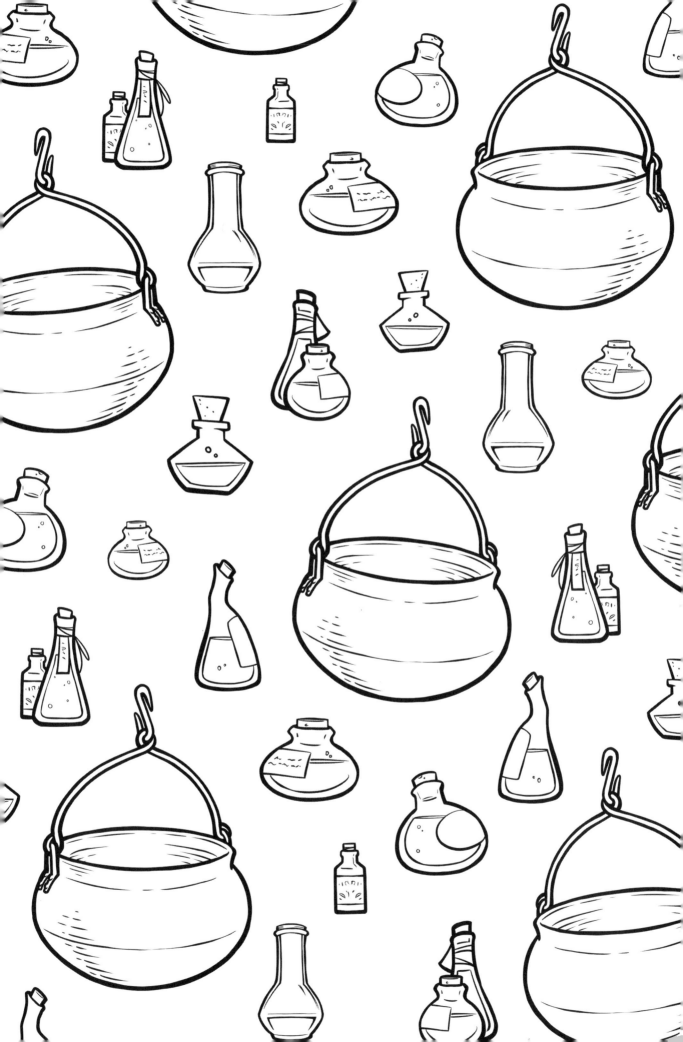

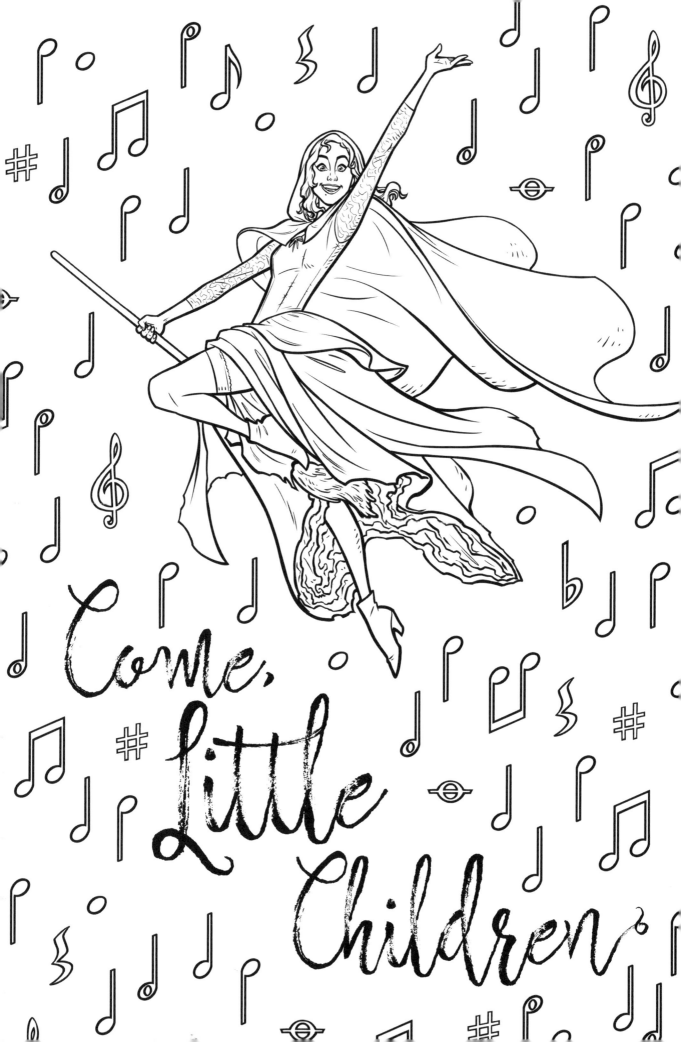

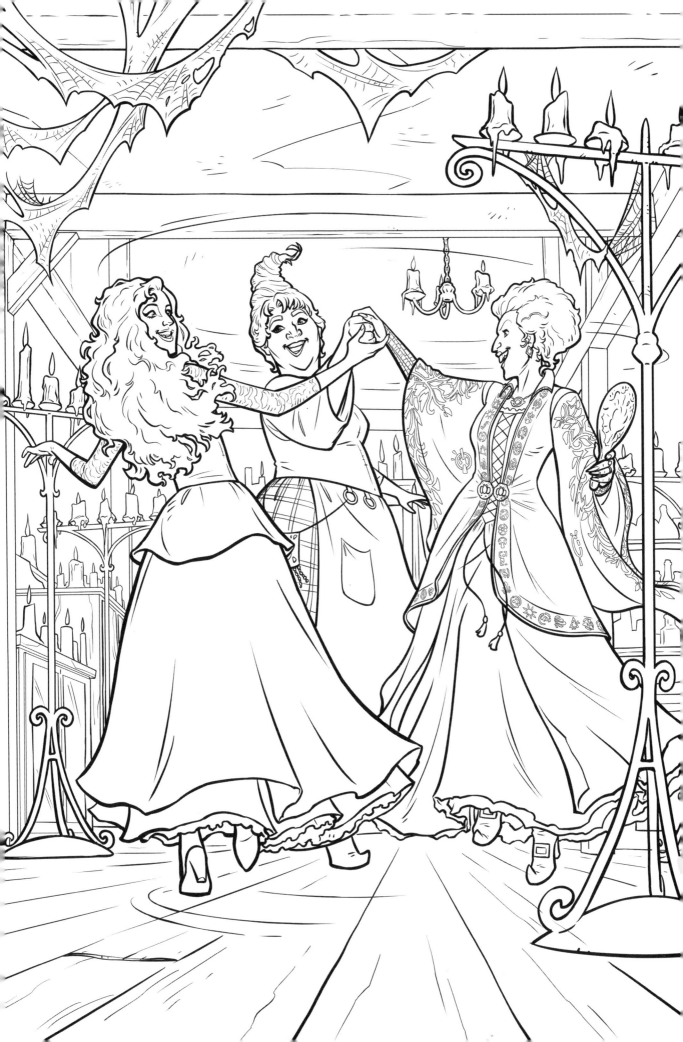

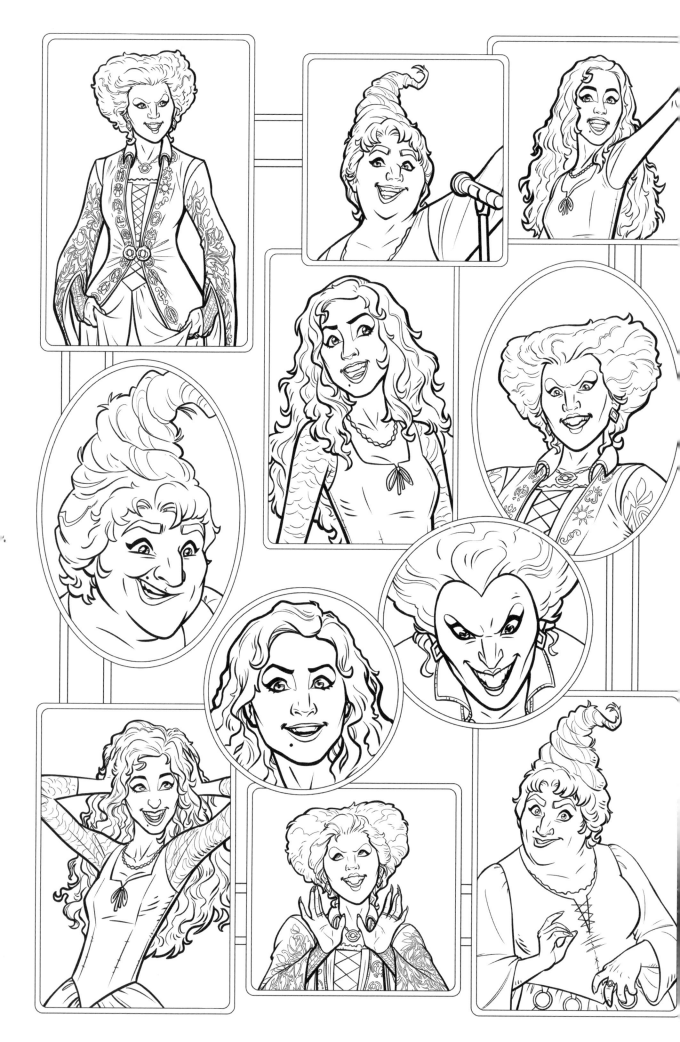

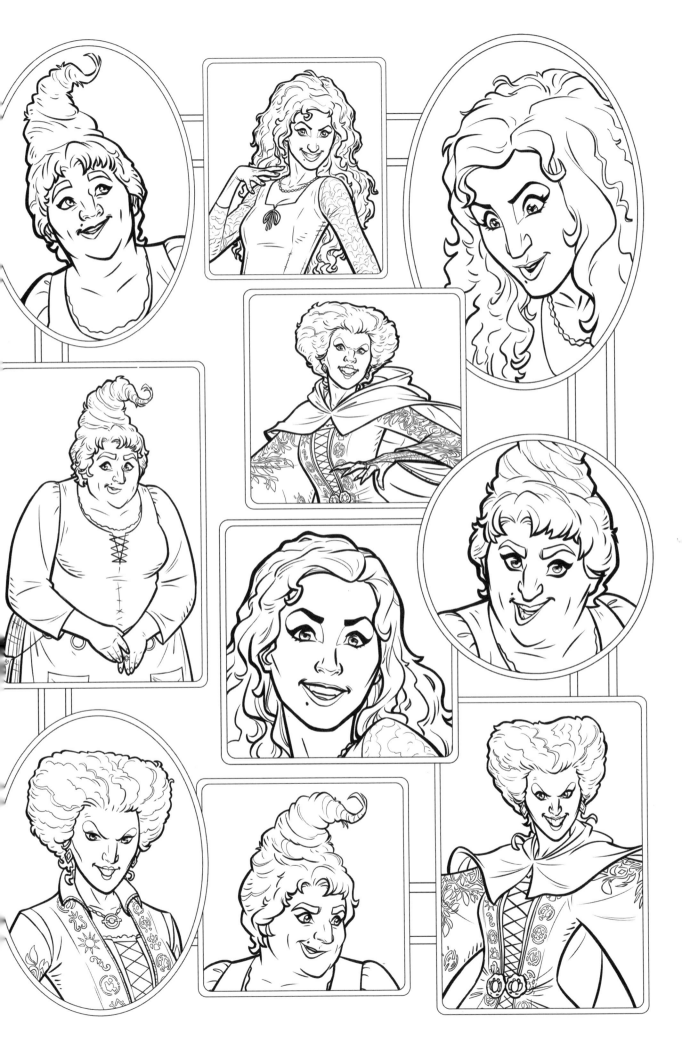

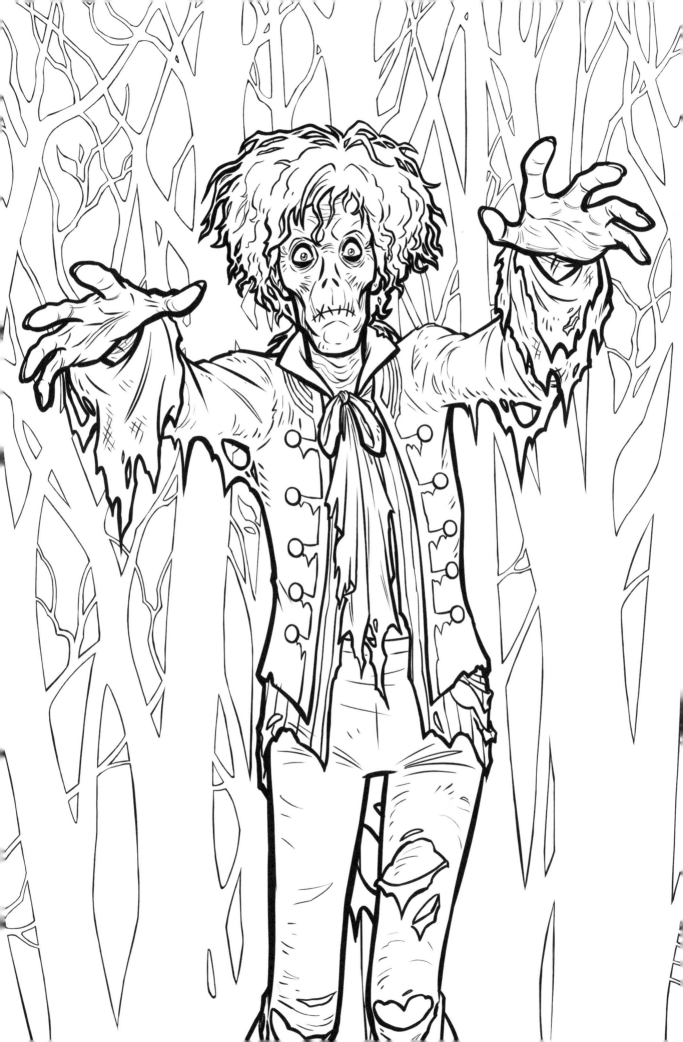

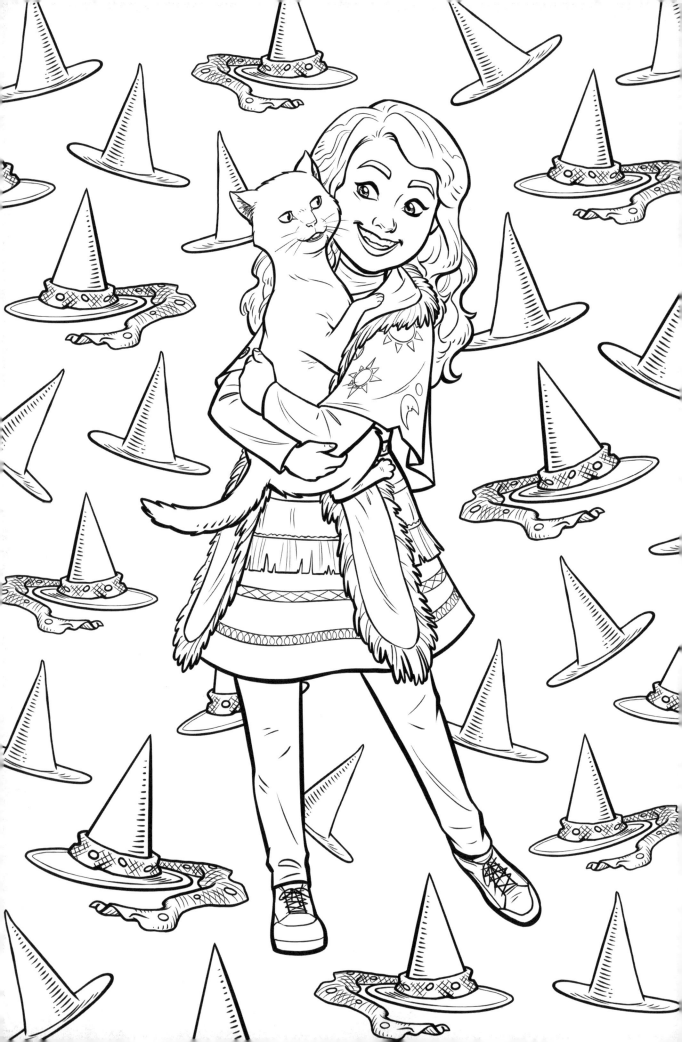

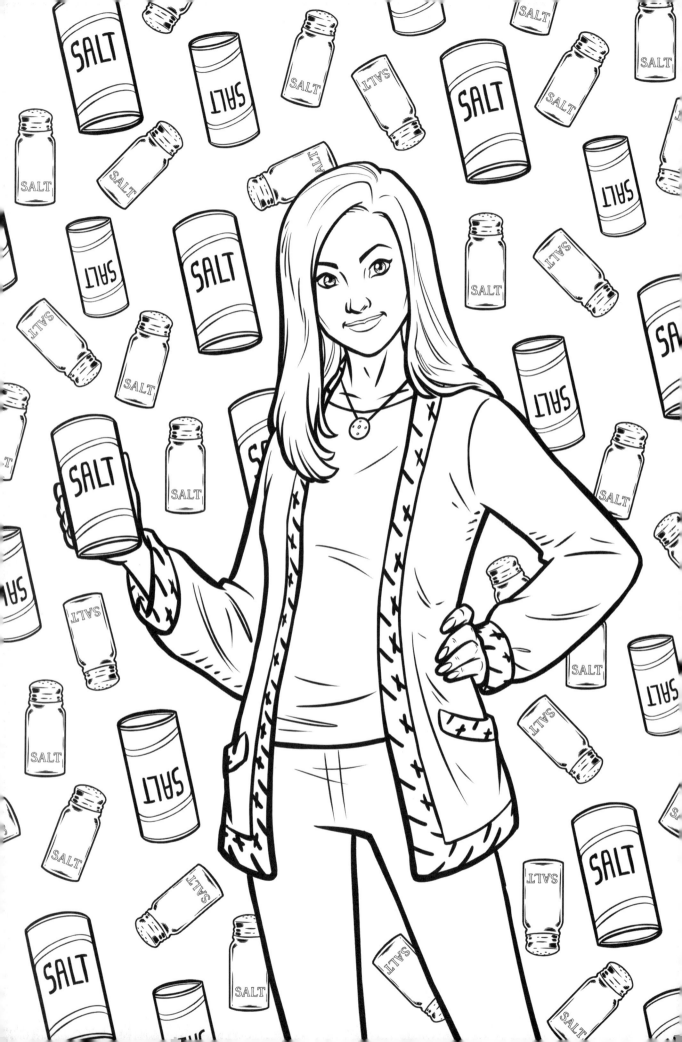

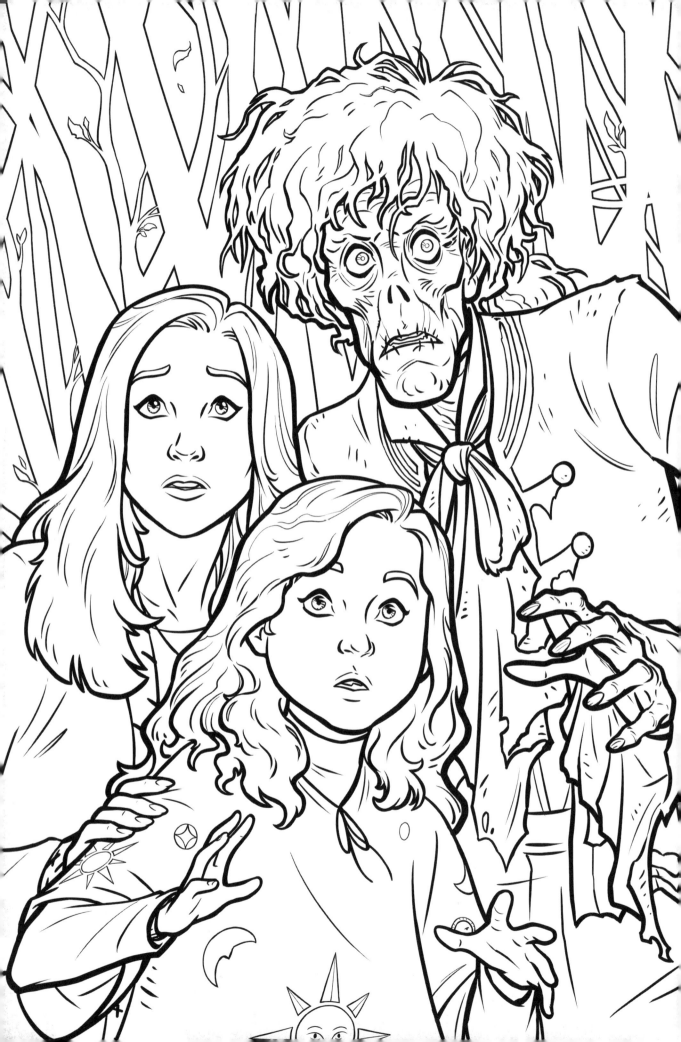

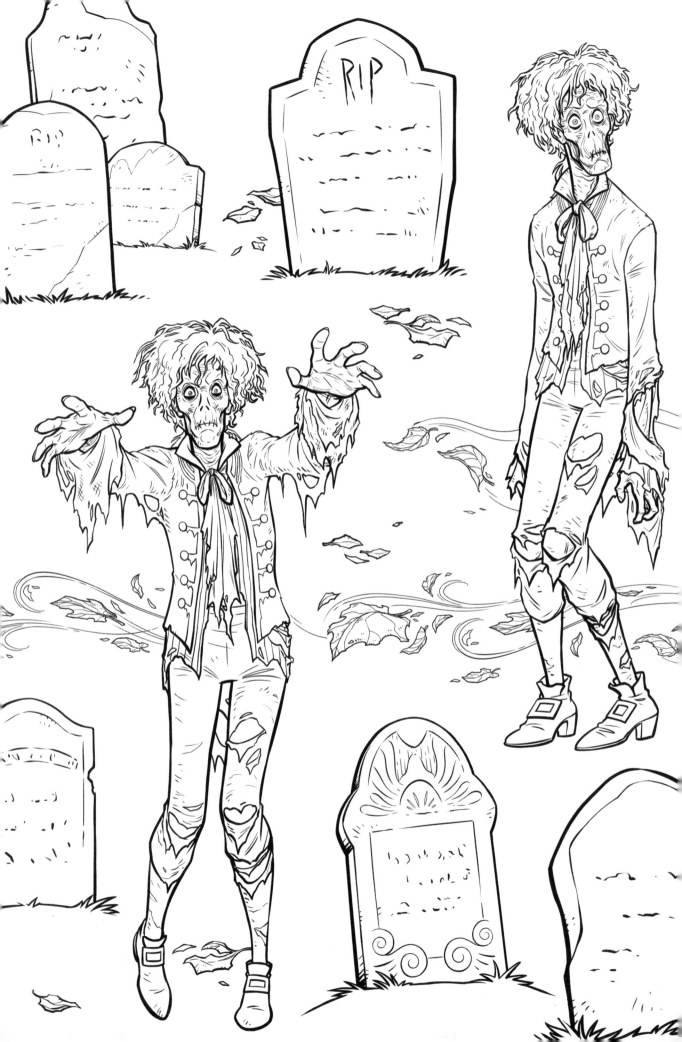

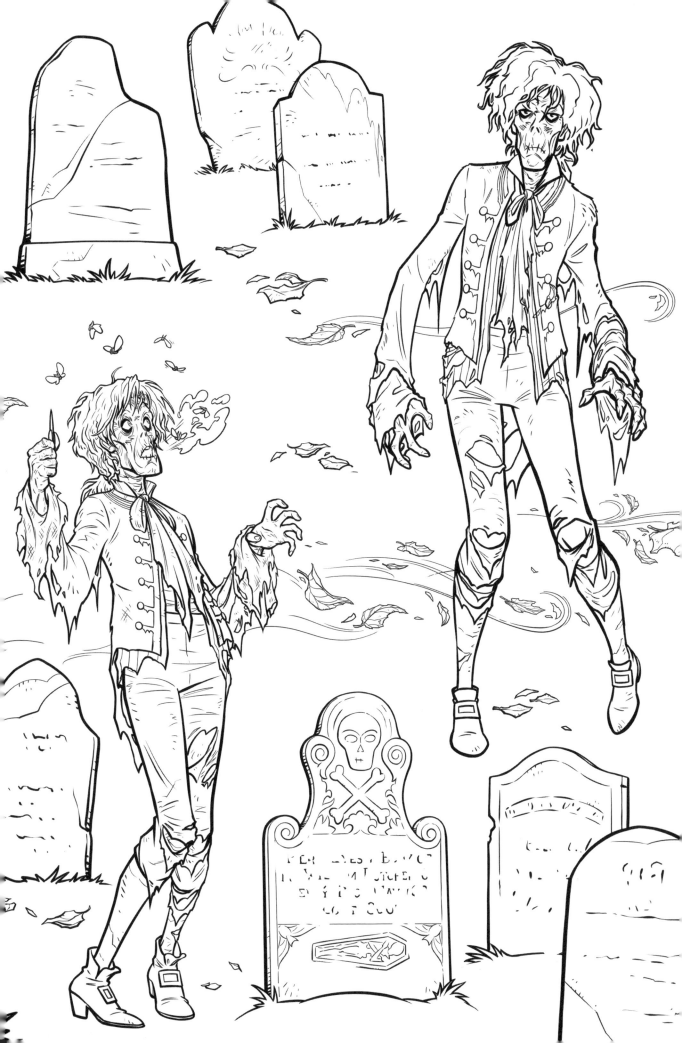

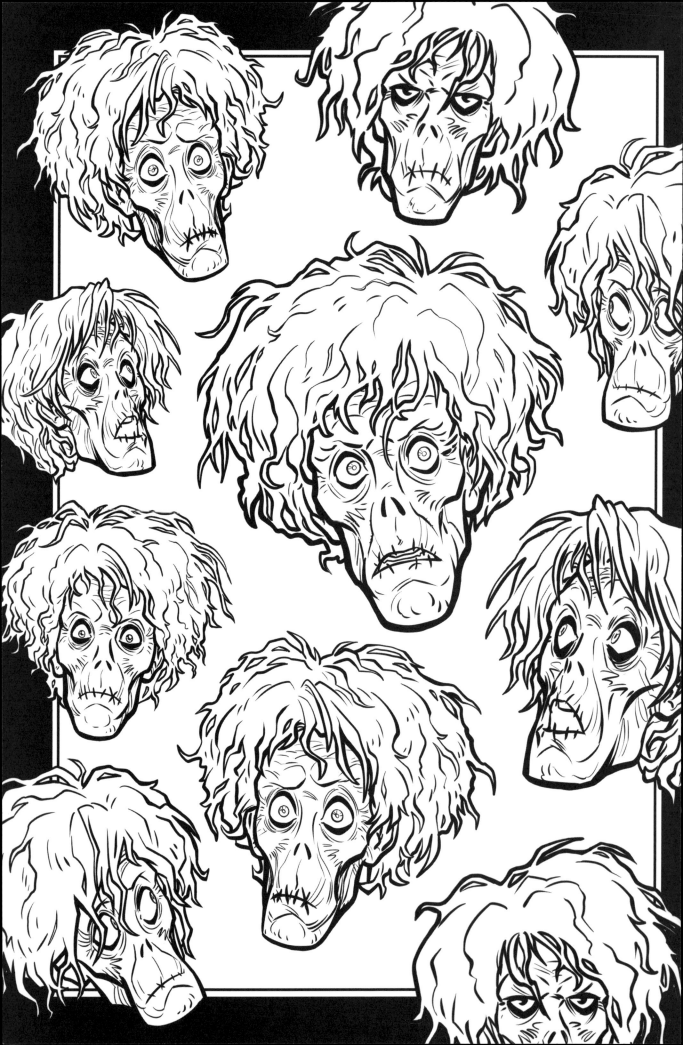

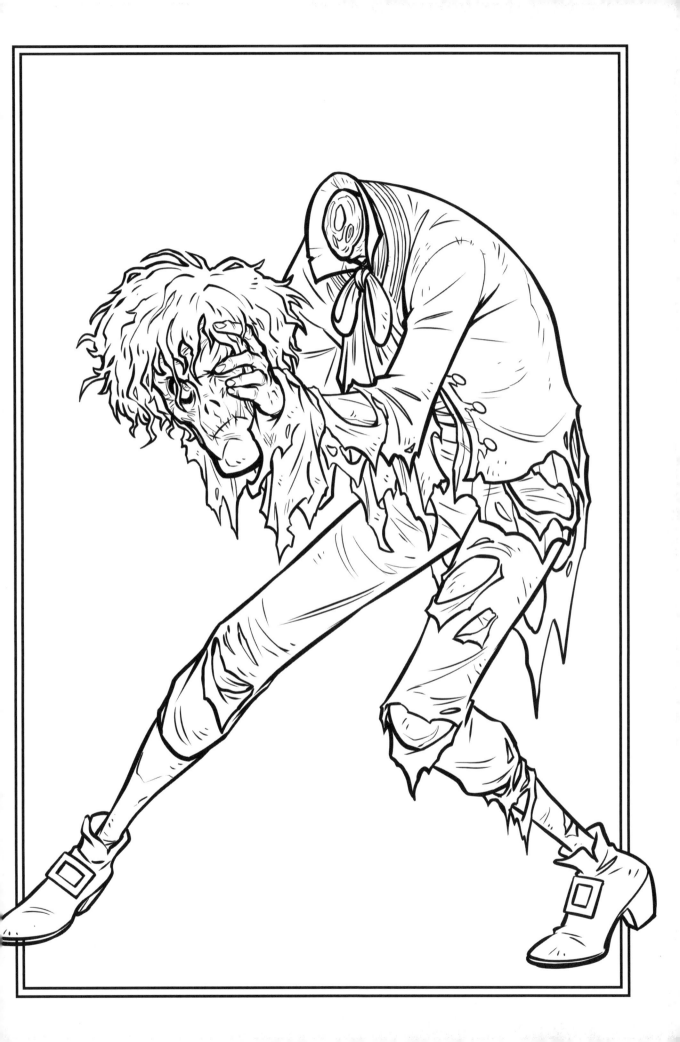

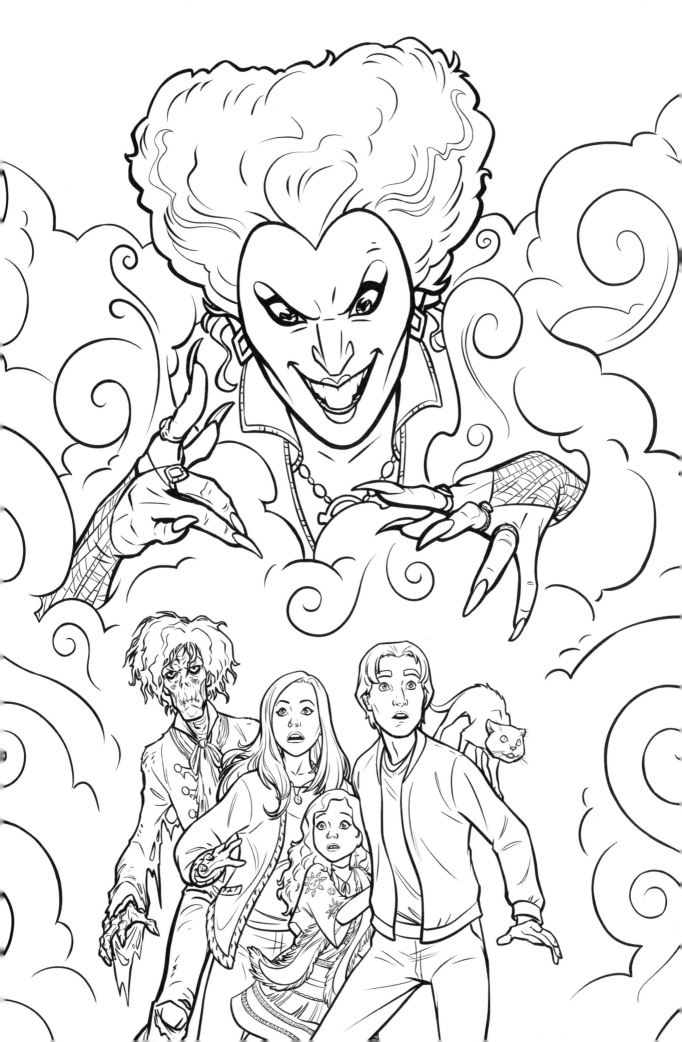

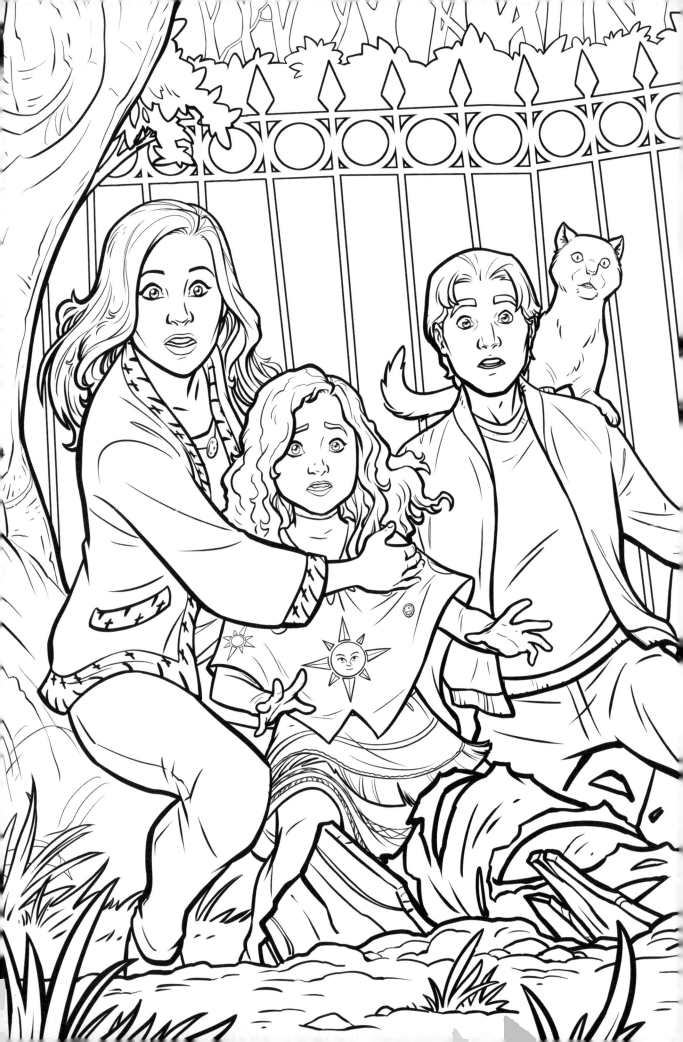

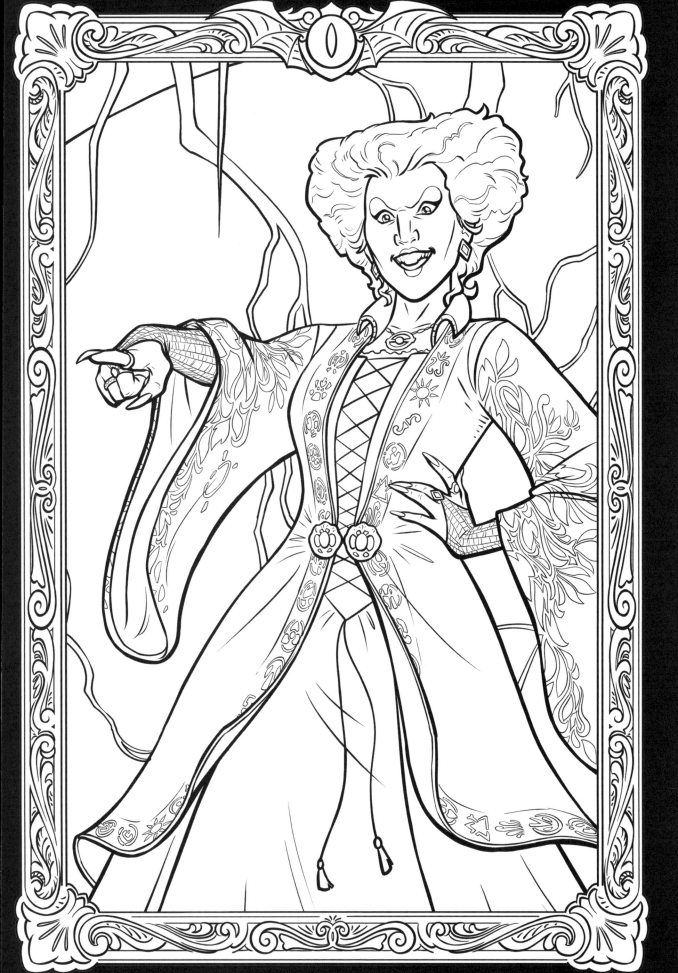

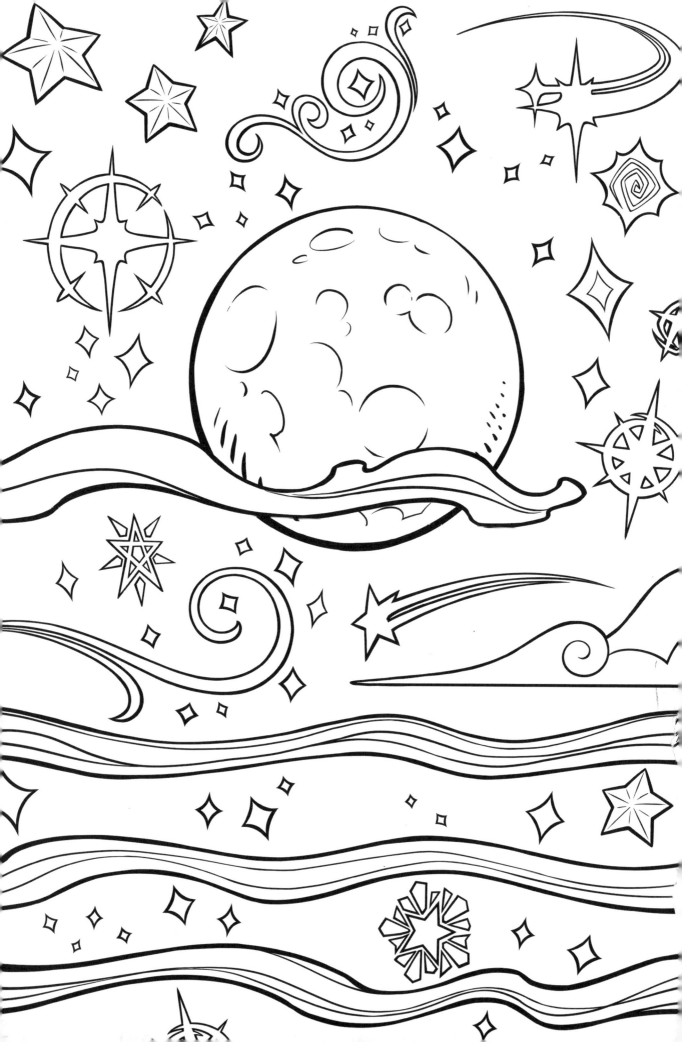

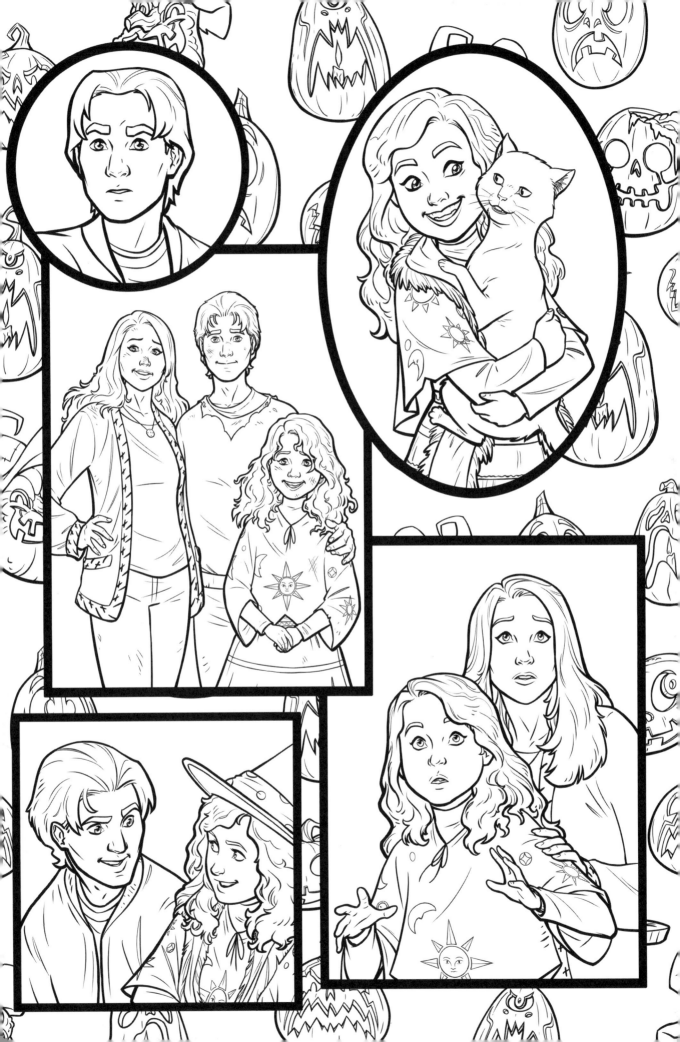

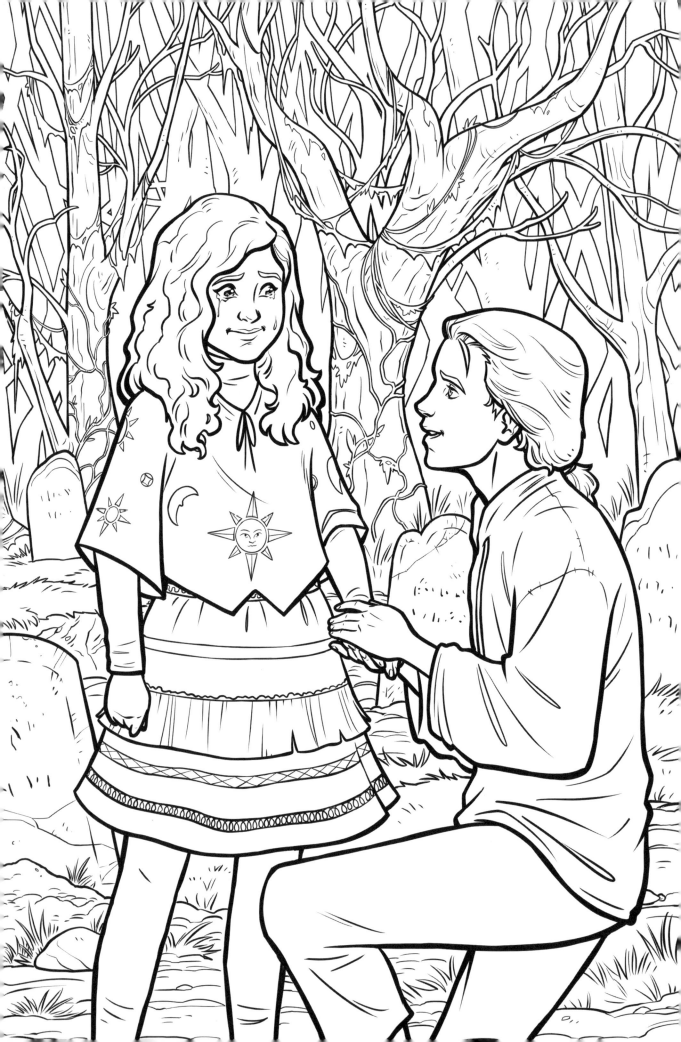

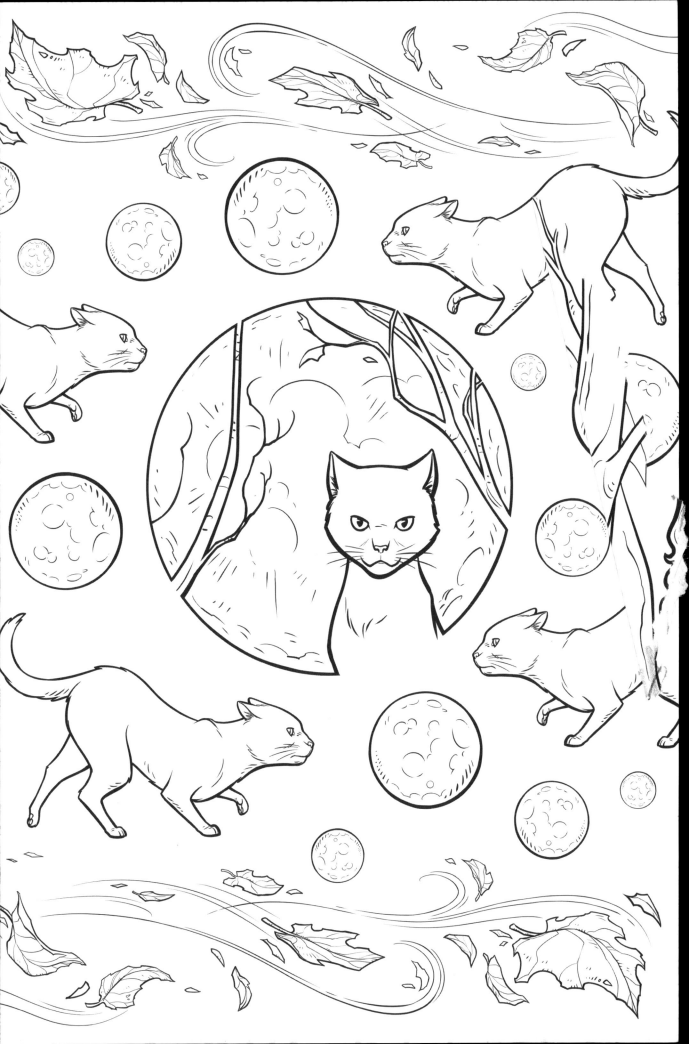

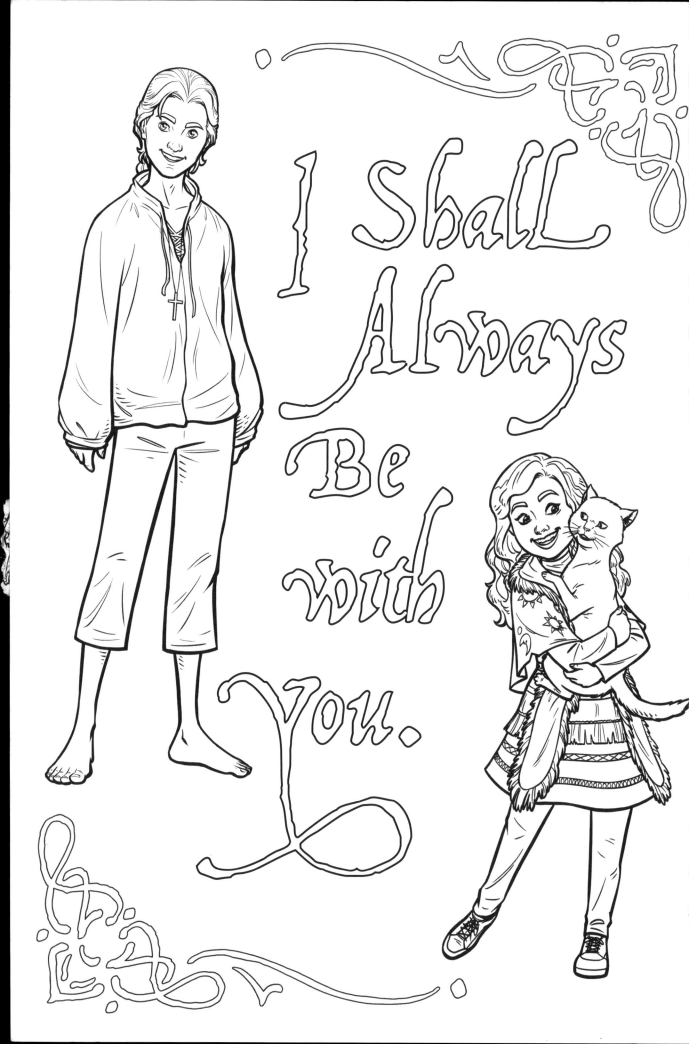

I Shall Always Be with You.

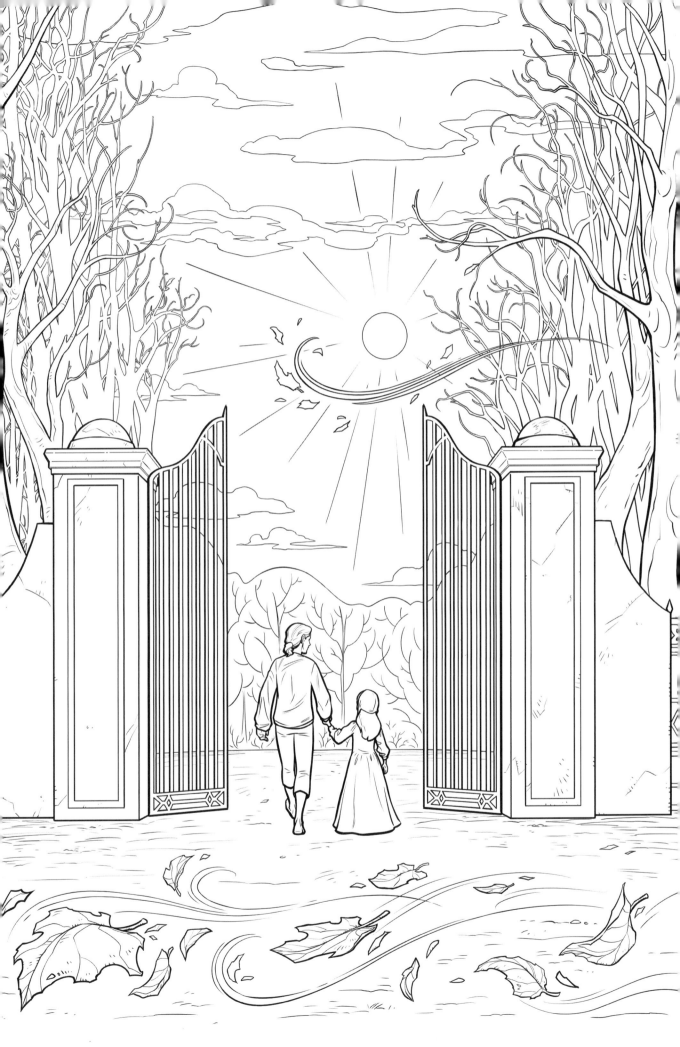

It's All Just a Bunch of Hocus Pocus!

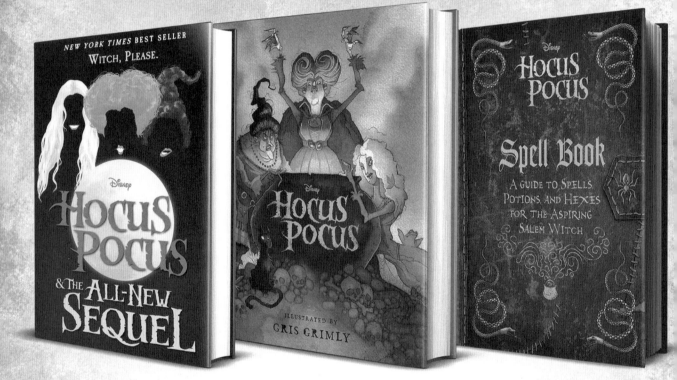

These books will put a spell on you!

Available Now

© Disney